CREATIVE PHOTOGRAPHIC LIGHTING

Consultant Editor Christopher Angeloglou

Collins

Published in 1981 by
William Collins Sons & Co Ltd
London · Glasgow · Sydney ·
Auckland · Johannesburg

Designed and produced for
William Collins Sons & Co Ltd
by Eaglemoss Publications Limited

First published in *You and Your Camera*
© 1981 by Eaglemoss Publications Limited

All rights reserved. No part of this publication
may be reproduced, stored in a retrieval
system, or transmitted, in any form or by any
means, electronic, mechanical, photocopying,
recording or otherwise, without the prior
written permission of the copyright holder.

ISBN 0 00 411686 0

Printed in Great Britain

CONTENTS

INTRODUCTION

Lighting is the element that can make or break a picture. *Creative Photographic Lighting,* part of a comprehensive series of titles for the amateur photographer, tells you everything you need to know about the lighting for your shots. It shows you how to deal with exposure in every lighting situation to create your desired effect.

Creative Photographic Lighting shows you how to make the best use of natural daylight and how to set off your subject to best advantage, whether you are shooting people, buildings or landscapes. You can use a simple reflector to enhance the dark parts of your picture, or you can use the shadowy areas to throw your subject into relief and make it appear more lifelike.

And what about your indoor shots? This book gives you countless hints on improving your flash and home studio lighting techniques. It anticipates the problems of mixing daylight with flash and tungsten, or other types of artificial lighting. Each new technique is accompanied by clear diagrams and simple illustrative shots. Finally, the book explores the exciting topic of night photography, where the subject is often the light source itself. There are plenty of hints on exposure and metering to help you succeed using mainly available light.

Introducing light: the source

One of the main components of a successful or failed photograph is the lighting. The power of light is so great that the appearance of a person or object can be altered beyond recognition merely by changing the lighting. Away from the studio, photographers tend to accept whatever lighting happens to exist, believing there is no alternative. After all, one can hardly shift the sun around or roll back the clouds. But there is in fact a great deal a photographer can do to gain control of existing light once the basic principles of lighting are understood.

Take an everyday example of a family on a beach, where the sun is out and every element throws complicated and hard-edged shadows which may be unflattering to the family group. The photographer can do several things to avoid this. A large beach umbrella, or any other large object, could be used to cast a shadow over the whole group to soften the hard-edged shadows. Exposure should be based on the areas which are now in shadow.

▼ Direct sunlight can be one of the trickiest light sources to handle: here *Clive Sawyer* uses it successfully by positioning himself so the main subject is 'spotlit' and all the potentially confusing cast shadows are lost in the dark background.

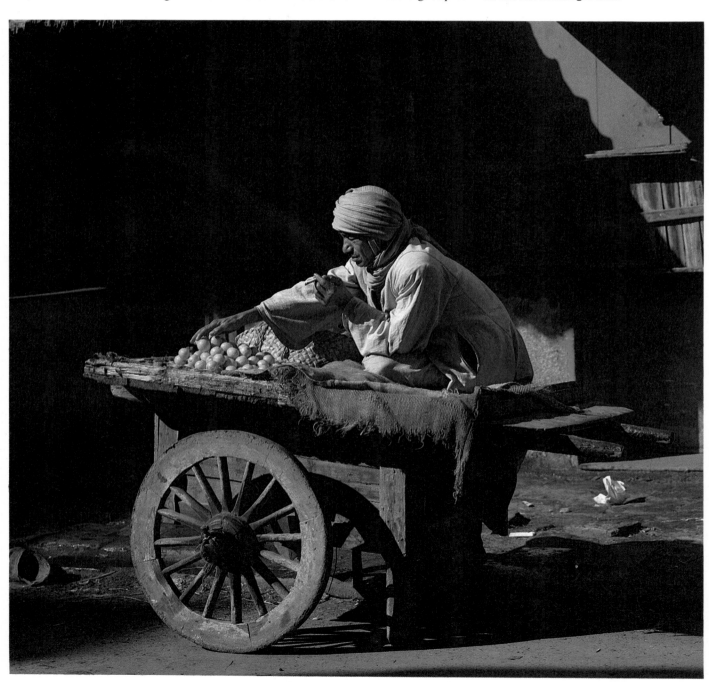

This is one solution and the person who understands the basic theory of lighting can quickly improvise many others, depending on the particular situation and the purpose for which the picture is intended. But first the photographer must think about what he wants to achieve in each individual case.

What is good lighting?
Good lighting for a passport photograph, a portrait, a prison record or an actor's publicity shot would clearly be different in each case. So good lighting has to be right for its particular purpose. The following four functions of lighting should be thought about, too.

The first function of lighting is simply to enable the photographer to see the subject, focus on it and expose the film. From this point of view, the more light there is the better: focusing is easier, there is greater depth of field and shorter shutter speeds are required, with less likelihood of camera shake. Slower speed film can be used, with finer grain and greater sharpness.

The second function is to convey information about the subject in terms of shape, size, colour, texture, and form, so that a two-dimensional photograph conveys the impression of 3-D. When eyes look at something, they see it in stereo. People can move their heads from side to side, enhancing the depth separation of the subject and clarifying the relative position of elements within the picture. Eyes can also concentrate on a small part of a scene and render it very sharply indeed. As a lens the eye-brain combination is of the finest quality.

Because the camera cannot operate in the same way as the eye, good lighting can help it to separate out these elements in a picture and communicate them to the viewer.

The third function of lighting is to comment by giving mood or atmosphere to a subject. It can imply the value or worthlessness of an object or suggest more indefinable qualities such as honesty or purity, happiness or misery. It can also subdue aspects and emphasize others. One has only to look at advertising photographs to see that these qualities can be attached to a subject or situation.

A fourth function is to give sensual pleasure. We enjoy looking at a high quality photograph in the same way as we enjoy hi-fi music and the way the lighting is handled is a vital element in such picture quality.

The danger with a 'small' light source such as direct sunlight, is that it can create irritating highlights and confusing shadows (right). If you block out the sun and use light reflected from other surfaces, shadows and highlights become more gradual and less aggressive. This gentler lighting is more suited to the subject.

The type of light source
Many different terms are used to describe lighting: hard, harsh, soft, diffuse, flat . . . These terms are often loosely used and it is easy to be misled. The expression 'flat lighting' is commonly used to cover three quite different forms of lighting: light from an overcast sky, the light from a flash unit mounted on the camera, and the

light reflected into the shadows by white walls or equivalent reflectors.

A better system for talking about lighting is to refer to the nature of the *effective light source*, whether a reflector or diffuser, sun or flashgun. In the example of the family group on the beach, initially the sun is the light source. When the subject is put into shadow the effective light source becomes the sky, beach and whatever reflective surfaces now illuminate it.

This effective light source is important because *the nature of the light source determines the quality of the lighting*, and the size of the light source is the most important factor.

A large light source is where the light is coming from almost every direction. It barely casts any shadow. Examples are the beach umbrella combination already described, or an overcast sky, a

Large light source

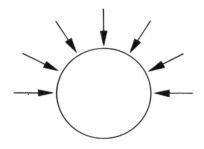

series of fluorescent lights on a white ceiling or any source large enough to make the light come from everywhere.

A small light source, at the other extreme, is directional and casts a hard-edged shadow. Examples are direct sun, a flashgun, a light bulb or a photoflood pointed directly at the subject. It may be a potentially large light source which is so far away that it appears small like bright sunlight.

Small light source

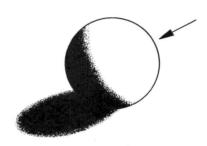

Medium light source. In between these two extremes there is an infinite range of light sources. But for the sake of simplicity just one intermediate size is defined here—a medium light source. This gives directional light but softer shadows than a small source.

The medium source is defined as being roughly as large as it is far away from the subject. For example, a window

acts as a medium source if it is, say, 1m wide and the subject is within a metre or two of it.

Medium lighting occurs indoors as well as outdoors. When sun strikes any light-coloured surface such as a wall, it becomes a medium light source. Sometimes, during heavily overcast weather, the clouds part to reveal a brilliantly lit cloud. This is an unusual and dramatic example of medium-source lighting. The same lighting is obtained artificially by reflecting (or diffusing) the primary light source by, or through, a piece of material, which should be roughly as big as it is far away from the subject.

Medium light source

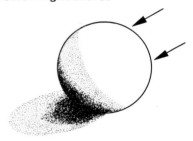

▼ An example of lighting from a large light source—an overcast sky—with scarcely any cast shadows. The colours stand out well and a basically complex picture is kept as simple as possible.

▲ The medium light source
—from the window behind—
gives better modelling and
softer shadows than a small
light source as shown in
the picture of a fruit seller
on the previous spread.

▶ Another example of
lighting from a medium
light source. But here
light from a window was
reflected on to the
subject by a sheet of
white paper.

Lighting different surfaces

When you look at your photographs you may feel that your lighting is not quite right but you don't know what to do about it. If so, you are not alone. Many photographers have the same problem. While there is no instant formula to make every picture come out perfectly, the photographer who knows what sort of lighting is produced by different sizes and angles of light sources, and how different surfaces respond to light, should be able to solve most lighting problems.

The last section defined the different types of light in terms of size. This section describes the three areas produced when light strikes an object—the highlight, lit and shadow areas—and how these areas differ according to the surface of the object—whether it is matt, shiny or somewhere in between. The next section will show the importance of the different angles or positions of the light source. An appreciation of these four aspects will enable you to get the lighting effects you want.

▲ A typical matt surface, with a minute, invisible highlight on each grain of sand. Colour appears in the lit area, while the edge of the shadow shows texture and form.

What light does

When directional light strikes an object three distinct areas are created: the highlight, the lit area and the shadow. (There may also be a cast shadow—but more about this later.) The combination of these areas provides the information which gives dimension, texture and colour to a photograph.

To see the character of each area, place an orange on a dark matt surface and light it from one side with a single, small light source such as an anglepoise lamp. Notice how the shape of the shadow and highlight show the shape of the object and that the colour comes from the lit area. Texture appears at the edges of the lit area where it merges into the highlight and shadow areas.

Types of surfaces

If you exchange the orange for a matt object such as a peach or a tennis ball, you will find that the highlight is practically invisible and that form and

texture are shown on the border of the shadow and lit areas. Now look at a shiny object made from glass or stainless steel, and you will notice the predominance of the highlight area and how the lit area merges into the shadow.

As these areas differ according to whether the object is matt, shiny or somewhere in between, surface will obviously influence your choice of lighting and its position according to which area you want to emphasize.

For the sake of simplicity, surfaces are broken down into three main types: shiny, matt and semi-matt. In reality, there are very few truly matt or truly shiny objects and under these headings fall surfaces which have a tendency towards mattness or shininess. The effects of lighting will be modified accordingly.

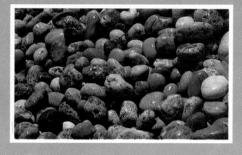

What light does

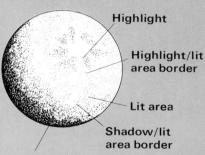

Highlight

Highlight/lit area border

Lit area

Shadow/lit area border

Shadow

Highlight : shows colour of light source
Highlight/lit area border : shows shape and texture of shiny and semi-matt objects
Lit area : shows colour of object
Shadow/lit area border : shows shape and texture of matt and semi-matt objects
Shadow : shows nothing

▼ A medium source studio light illuminates a variety of fruit surfaces, ranging from the matt skin of the plum to the shiny, polished apple.
Now look at the fruit in conjunction with the diagram on the left. Notice the difference between highlight, lit area and shadow on the various surfaces, seeing especially which areas give the most texture and form, and which give the most colour. (On the semi-matt orange form and texture show up on the borders of the highlight/lit area and shadow/lit area, while on the apple only the edge of the highlight gives this information.)

▲ Dry pebbles are matt, while water adds shine so that both the highlight border and the shadow border show shape and texture.

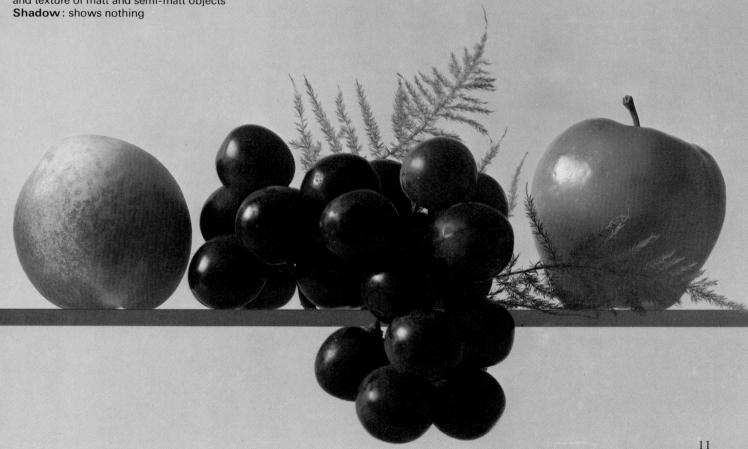

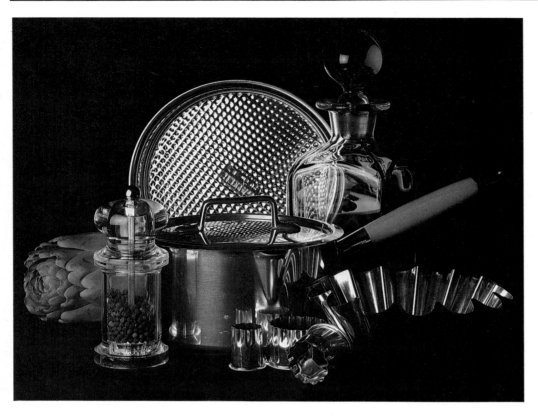

◄ The objects in this photograph are shiny apart from the artichoke and brushed aluminium saucepan. Notice that it is through the highlights that we realize the shape and texture of these shiny objects. The lighting used was a medium sized rectangular strobe (studio flash) and the shape of the light is seen clearly on the rounded bottle stopper. If a small light source had been used this picture would have been unreadable—just a confusion of tiny, hard highlights.

► The bread crock is a good example of a matt object where the highlight is not obvious and where texture is clearest on the shadow/lit area border. Compare this with the semi-matt onion which has a distinct highlight, and texture visible on both borders.

Shiny objects

In the case of shiny surfaces, such as tinfoil, mirror or glass, the highlight shows up very strongly while the lit area and shadow area tend to merge into one. For this reason, when lighting shiny objects the photographer needs to concentrate on the shape, size and position of the highlights. These highlights are reflections of the light source and do not show the colour of the object. But information comes from the reflection, which is distorted according to the shape of the object. The brain, seeing this distortion instantly recognizes the shape of the object.

The texture of a shiny object, or lack of it, appears at the border of the lit area and highlight.

Lighting suggestions: when small-source lighting is used a small highlight is produced. This does little to describe the shape of the object, so small light sources are not usually used with shiny objects. In fact, for many years photographers tended to construct the largest possible light source when photographing shiny objects such as cutlery or stainless steel kitchenware. More recently there has been a swing towards using a medium light source, particularly a source with a neat, clean shape such as a rectangle.

Matt objects

With matt objects, such as a brick or tennis ball, the surface is finely broken up in many directions and there is not just one highlight but thousands or millions of minute ones, usually too small to be seen as such. So the highlights are not much help to the photographer. (A comparison between the two still lives on this spread shows clearly the difference between the highlights of shiny and matt objects.) The lit area shows the colour of the object but is largely flat in appearance, while the shadow itself does not have any modelling or texture—if there appears to be some it is from a second light source, such as a nearby reflecting surface. It is the edge of the shadow, where the lit area and shadow merge, which is full of information.

Lighting suggestions: if it is texture that you want to emphasize you need a strong, well-placed lit area/shadow border. This means choosing a small, or medium, light source and positioning it so that the border falls on a prominent area of the photograph. Top, bottom or side lighting will put the border between shadow and lit area roughly in the centre of the object (the next section discusses lighting positions).

Semi-matt objects

Semi-matt (or semi-shiny) covers the majority of surfaces which are not predominantly·matt or predominantly shiny but a mixture of the two. Copper and brass (not highly polished), glossy paint, most plastics, human skin, oranges and many other fruit, are examples of semi-matt surfaces.

To a greater or lesser extent both the highlight and shadow areas are clearly distinguishable from the lit area. The highlight is the same colour as the light source, the shadow is black (unless light from another direction is shining on to the shadow area) and the lit area shows the colour.

Texture appears in both the highlight/lit area and the lit area/shadow border. The amount of texture revealed by either border will depend on the extent of the highlight or shadow.

Lighting suggestions: if you want to show up the subject's colour above all else, the lighting has to be arranged so that the maximum amount of lit area is visible. This means two things:

1 Keeping down the shadow area by using more frontal or half-front lighting (the next section will go into more detail on this).

2 Keeping down the size of the highlight by using a small light source.

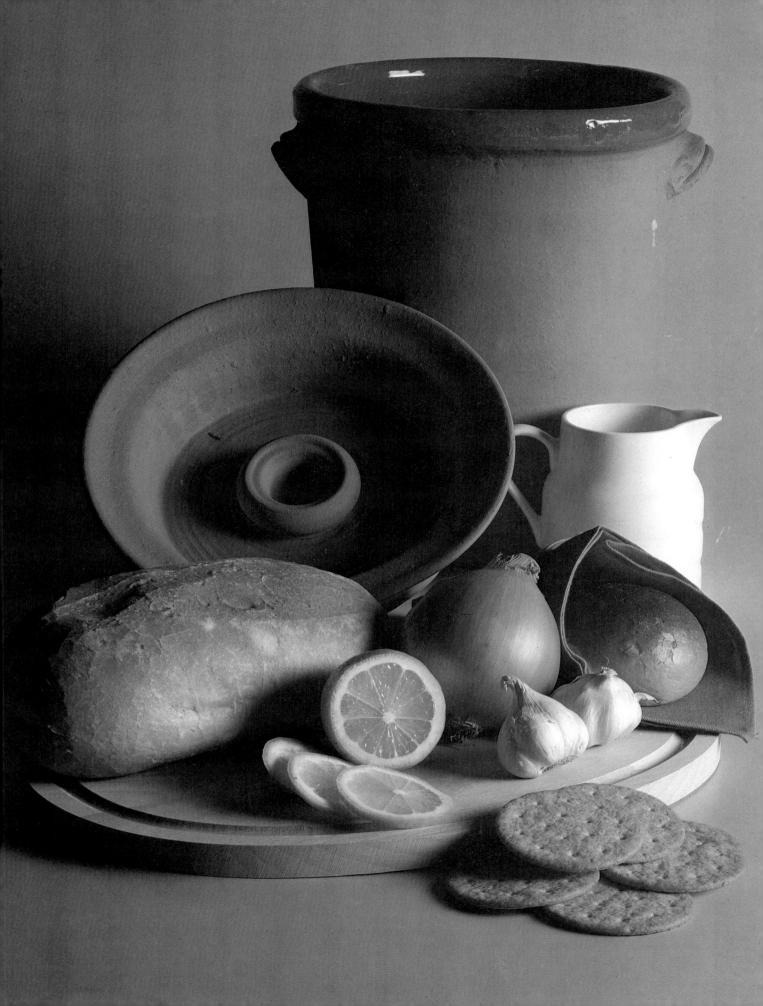

Positioning the light source

While the size of the light source is probably the main factor affecting the quality of lighting, its position is obviously also very important. A glance at the three photographs here, illustrating a scene at three different times of day, shows what a vast difference the angle of the light can make; notice the strong highlight in one, the shadow in another, the colour in the third, and how the details vary with the change of lighting for each of the pictures.

With small light sources, or with shiny objects, small changes in position can alter lighting significantly, but in most cases moving the light up or down a few centimetres does not have a very great effect. So it is usually more helpful to think in terms of five or six basic lighting positions, such as front, top, side, half-side, back lighting and perhaps lighting from below.

Choosing the angle

The position of the light has two quite separate effects. One effect is *subjective*; lighting from different angles can be associated with different situations and can carry definite emotive connotations. For instance, lighting a face from below with a small light source can look very sinister, while top lighting can create a reverential atmosphere.

The other effect of the position of light is *objective*; it concerns the amount and quality of information that lighting conveys. More simply, as the light moves round an object, so the viewer is presented with more or less shadow, more or less lit area, more or less highlight.

Your choice of angle will be determined by where you want the highlight, shadow or lit area to fall and what type of information you wish to convey about the subject.

With all shiny objects, for example, it is the shape and break up of the edge of the highlight which reveals the shape and texture of the subject. So a flat shiny surface such as a wet pavement or wet sand will not usually show much surface detail unless a highlight or highlights can be positioned to appear on it (look again at the examples of the seascape photographed at different times of the day).

Positioning the lit area

Since the lit area carries the colour of an object, front or half-front lighting, which shows the largest amount of lit area, shows the most colour.

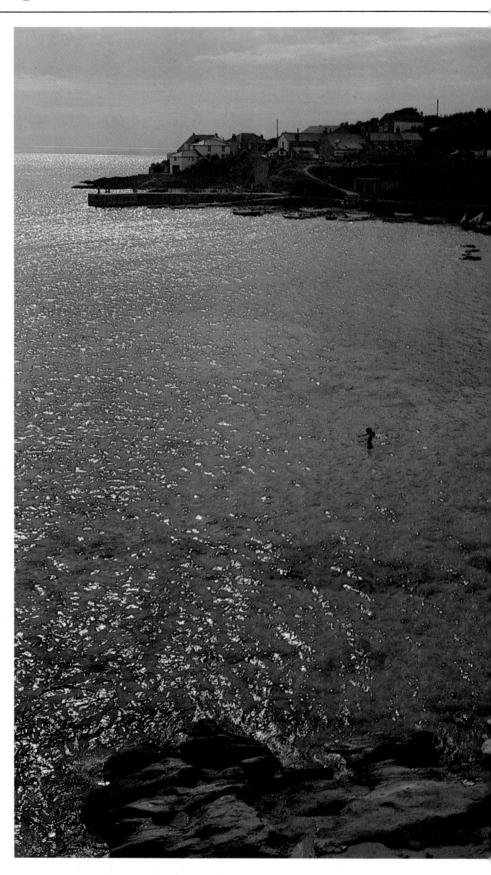

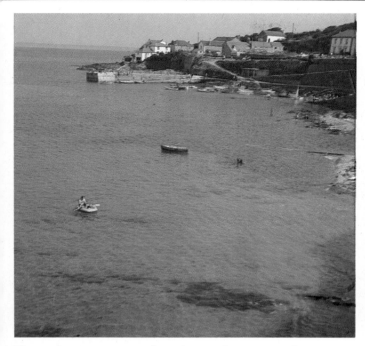

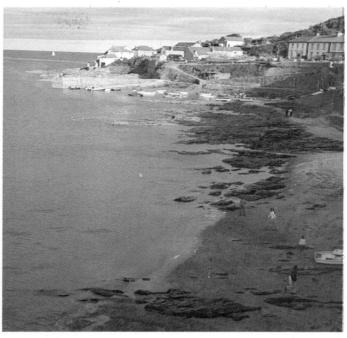

These three seascapes show how colour saturation, texture, modelling and tonal relationships (dark and light areas) change with the angle of the light.

The photograph on the left, with its small source back lighting, has the least overall detail but the light is in a position where it reflects on the shiny surface of the sea, emphasizing the waves. The large source front lighting from a cloudy sky (right) gives good colour saturation on the headland (notice the greenery and red life belt). The side lit view (centre) has less colour saturation but more detail (see detailing on the pier, central steps and boats).

▶ The oranges show what happens when a semi-matt object is lit by small source lighting from five different angles.

TOP AND SIDE LIGHTING: half the object in shadow. Good for texture and modelling.

BACK LIGHTING: very large shadow area and small, but very strong, highlight. Lit area/shadow border indicates shape and texture well.

FRONT LIGHTING: good colour but little modelling or texture.

HALF-SIDE LIGHTING: strikes a balance between side and front.

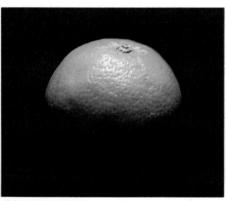

TOP LIGHTING

SIDE LIGHTING

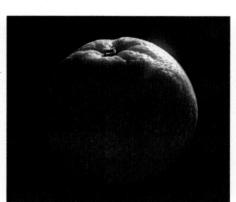

BACK LIGHTING

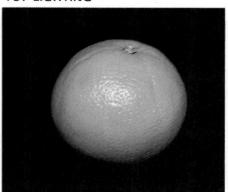

FRONT LIGHTING

HALF-SIDE LIGHTING

Positioning the highlight

The position of the highlight depends on the position of the light source. A rounded object will always have the highlight visible somewhere on it. A flat object may lose the highlight into its edge. But most objects are a combination of flat and rounded surfaces. With such objects the highlight can be placed deliberately to fall on an area where it is most useful.

For example, in portraiture you may want to emphasize furrows on the brow or wrinkles at the corners of the eyes with highlights.

The edges of dark objects photographed against dark backgrounds can be strengthened by altering the angle of your light source so that you run a highlight along them. Of course, this technique can only work when the highlight is strong enough to stand out clearly; that is, with a shiny or semi-shiny object.

Positioning the shadow

With matt objects, and to some extent with semi-matt objects, it is the positioning of the shadow which produces modelling of shape and texture—or rather the area where the lit area merges into the shadow. In exactly the same way as you position the edge of the highlight to fall across a flat surface of shiny material, so the edge of the shadow can be used.

For example, when photographing the front of a building the architectural photographer will usually wait for the sun to be in a position where the light is cutting across the surface, picking up all the fine detail. A few minutes earlier, the front may have been in shadow and the only light on it would have been large source light reflected from the surrounding area and the sky. A few minutes later the front would be completely in the lit area—good for colour but unlikely to yield fine detail in terms of fine shape and texture. But for a few minutes the whole facet sits on the edge of the shadow. Similarly, the still-life photographer turns the slice of bread until the edge of the shadow lies across it and the portraitist runs the edge down the wrinkles of his sitter's face, as shown here.

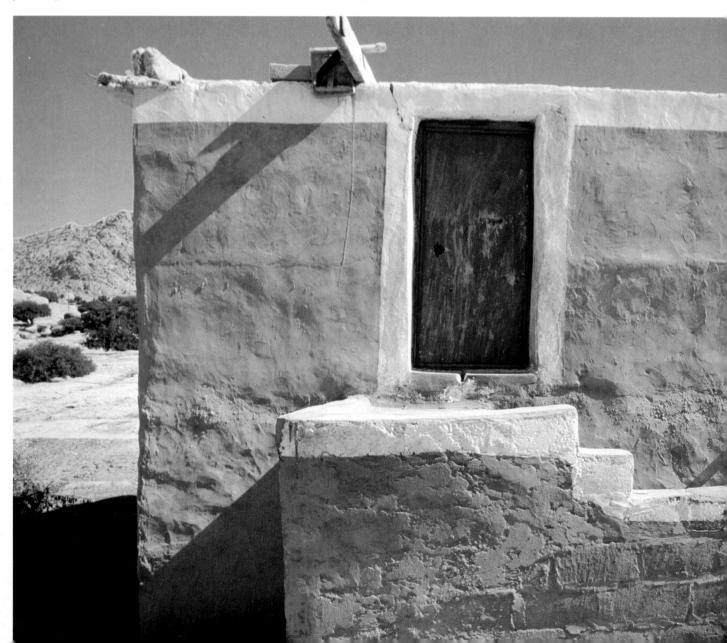

► The head is turned so that it is lit from the side. This causes the man's wrinkles to be emphasized by highlights.

▼ Right: this photograph shows street decorations reflected in a car. The position of the highlights could be changed by moving the camera from side to side.

▼ Left: the sun is just coming round the right side of the building, placing the whole façade on the edge of the shadow and picking up all the details on the surface.

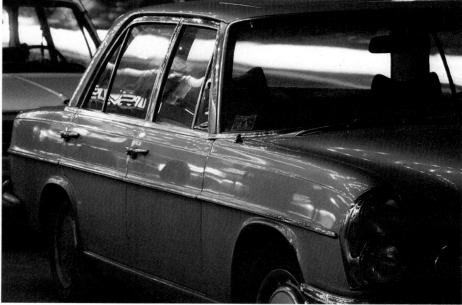

Side lighting

With side lighting the edge of the shadow tends to run down the centre of each object in fullest view of the camera and this is the most commonly used angle where texture is the main feature. (See pages 42 and 43.)

Half-side lighting

Half-side lighting keeps the edge of the shadow in a prominent view, while offering a little more of the lit area and less shadow than side lighting. This makes it a useful working angle, and probably more pictures are taken with half-side lighting than any other kind.

Front lighting

With front lighting there is virtually no shadow area and the edge of the shadow is almost out of sight. It thus gives very little texture or modelling to the subject, although it does give good colour saturation, as the lit area is well to the fore. The highlight is practically in the centre of each object, and this can be disturbing, especially with portraits, for example, where it appears almost in the centre of the eyes. This is the lighting given by on-camera flash (except where bounce-flash techniques are used).

Medical photographers use front lighting because the good colour saturation and absence of shadow ensure that pigmentation will show up well, and that no detail will be lost in shadow. They make do without texture and shape information. Press photographers use front lighting because it is simple to use under pressure.

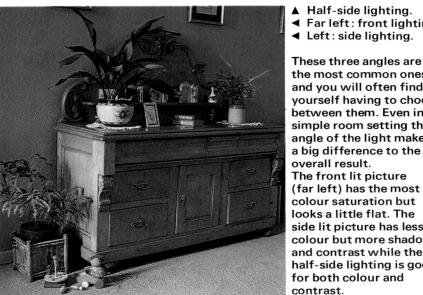

▲ Half-side lighting.
◀ Far left: front lighting.
◀ Left: side lighting.

These three angles are the most common ones, and you will often find yourself having to choose between them. Even in a simple room setting the angle of the light makes a big difference to the overall result.
The front lit picture (far left) has the most colour saturation but looks a little flat. The side lit picture has less colour but more shadow and contrast while the half-side lighting is good for both colour and contrast.

Top lighting

Top lighting is really the same as side lighting from above: that is, the edge of the shadow tends to run across the centre of each object in fullest view of the camera, again leaving half the object in shadow.

While there is no general objective difference between top and side lighting there is a difference in the particular effects. For instance, people nearly always keep their heads upright, and top lighting does not seem to suit the layout of the human face too well: the eyes and jowl darken, the nose and cranium lighten and the result is not generally felt to be pleasing. This is particularly unfortunate because top lighting—from an overcast sky—is one of the most common forms of natural lighting.

Apart from tilting your subject over on his or her side, the best solution is to either add light in or take it out so that the lighting is no longer simply from the top. For example, a reflector such as a large white or shiny object could be used to add front lighting, or something dark such as an umbrella could be manoeuvred into position above the subject's head to reduce the lighting. However, with less overall light, you might find that exposure problems arise.

Back lighting

With back lighting most of the subject lies within the shadow area, which contains no information (unless a second light source, like a reflector, picks it up). The lit area is so small as to be overwhelmed by the intense highlight. (See page 15.)

Although the highlight is small it becomes more dominant as the light tends toward back lighting. This is because any surface becomes more reflective when light hits it at a shallow angle. The effect is so powerful that even seemingly totally matt objects can acquire a highlight when back lit, so this angle is often used to bring life to a dull subject.

The double effect of obscuring a lot of unwanted detail while creating plenty of highlight has made back lighting a favourite among many photographers. It works like magic. But that is not all. Where there is a succession of shapes, one behind the other, receding into the distance—for example, ranges of hills, folds of fabric or wet sand—back lighting separates and spaces them out by placing each highlight against the shadow area of the shape beyond it; this in turn grades through lit area to highlight, and so on.

▲ Top lighting does not usually suit the human face in an upright position. The photographer has got round this problem by angling the model's face so that the lighting becomes more flattering.

► Back lighting outlines the heads, while highlights separate them from the crowd behind. The faces would be black if it were not for reflection from the surroundings which provides secondary lighting from the front.

Small source lighting

Lighting and the ability to use it well is important for successful pictures, and the size of the light source has probably more effect on the final lighting than any other single factor. The three basic sizes—small, medium and large source—have been described briefly already. The three sections which follow take each in turn, describing their advantages and disadvantages and how to overcome the different problems which may arise.

What it is

Small source lighting—also known as hard lighting—is recognized by its strong direction and hard-edged shadows. It is probably the most commonly found lighting because bright sunlight itself is small source.

In spite of the enormous size of the sun, it is so far away that it appears quite small from the subject's position. And the brightness of strong sunlight has the directional and shadow qualities of small source lighting.

Other small light sources are direct flash, domestic lamps and studio lamps, unless they are in large reflectors. Again, the test is: do they cast a hard-edged shadow?

What it does

Because of the strong well-defined shadows this lighting both casts and forms on the object itself, small light sources tend to make a picture more complicated. Highlights are small, bright and hard. The dividing line between lit area and shadow is abrupt, with little space for the subtle tones that give a feeling of roundness to an object.

But what it lacks in subtlety it makes up for in visibility. It also shows up every small flaw it illuminates.

The advantages

Though small source lighting may present some problems, it is ideal for certain situations.

Small simple objects respond well to it when the tendency to complicate subjects becomes an advantage. The sharp-edged shadows and pointillistic highlights inject some life into very simple subjects which might otherwise be boring.

Colour saturation is good and fine texture can be picked out, though medium source side lighting can often be as effective here.

Small source lighting can be projected considerable distances and its distribution is easy to control. Spotlights

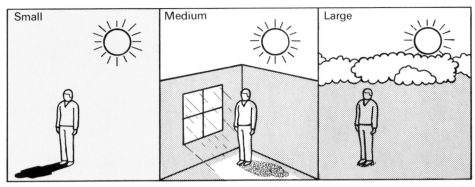

▲ The different types of light source can be distinguished by their shadows. To simplify the illustration, only cast shadows are shown but the lighting has similar effects on all shadows. A small light source casts a hard edged shadow, a medium light source a distinct, but soft-edged, shadow, while large source lighting produces almost no shadow.

▼ The jug was lit by a small-source, half-side lighting from the left. Note the small but distinct highlight, the hard shadow edge and good texture. *Malkolm Warrington*

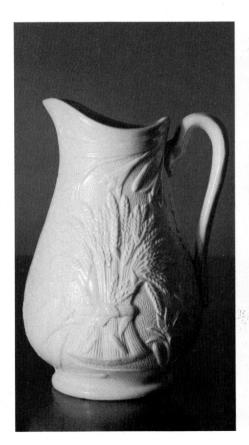

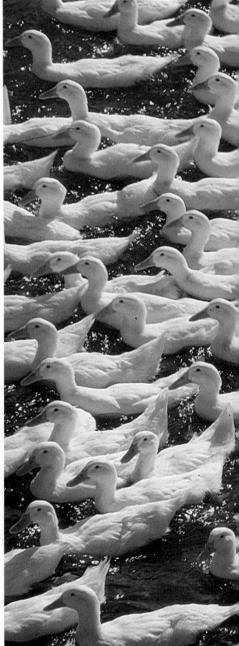

◀ High bright sunshine from the left makes the most of the gloss paint and emphasizes texture on all surfaces. *Suzanne Hill*

▼ Strong directional sunlight results in masses of tiny highlights which break up the surface of the water rather like a pointillistic painting. The shadow edges on the ducks are softened by the feathers, producing a good contrast with the hard highlights. *Suzanne Hill*

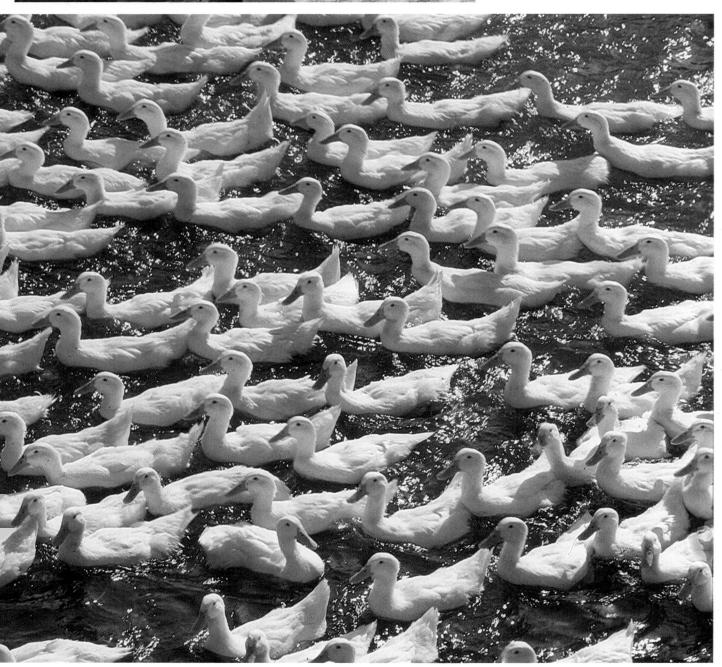

are always small source for this reason. Television studios use nothing else, although film lighting technicians have discovered medium source lighting.

Water-spray or rain can only produce a rainbow with small source lighting. Flare-spots can only be obtained with small source lighting. Medium or large source lighting produces flare which has no strong pattern, but simply 'whites out' the picture to some extent.

Disadvantages

Because of the complicated, hard-edged shadows and the ability to pick up every defect, small source lighting is not always the most flattering, especially for photographing people.

On the other hand, it is one of the easiest types of lighting to control. Take, for example, a sunny day on a beach where a photographer wants to take a picture of her husband and children. The hard shadow edge cuts across their faces. Stress lines are recorded mercilessly. If it is hot, any sweat on the face is picked out by thousands of tiny, hard highlights.

Because of the excellent colour saturation, a red nose appears redder than ever. Throughout the whole scene, there is a lack of modelling: the baby's podgy limbs are not attractive because there is no feeling of roundness.

Changing the lighting

One way to overcome this problem is to change from a small source to a medium or large source light. To do this, the photographer has to find something to block out the direct sunlight. Exactly how this might be done depends on the actual situation; a beach umbrella might be available to put over the group, or perhaps they

▶ **Strong shadows intensify the angles of the buildings and dramatize perspective.** *Adam Woolfitt*

▼ **Provided there is enough reflected light, placing the subject in shade is a way of losing those harsh unflattering shadows. Here the wall on the left acts as a reflector.** *Tim Megarry*

▶ The subject has her back to the hard sunlight, and her face is lit by softer light reflected from surfaces all round. *John Garrett*

▶ Below: strong directional light causes unflattering shadows under chin, eyes and nose and picks up every detail —even single strands of hair. *Richard Greenhill*

could be moved into the shadow of a cliff or awning.

Failing this, the photographer might just have to wait until the sun is diffused by a cloud or haze. In each case, the principle is the same—a change from small to large or medium source. The effect of this is detailed in the sections on medium source and large source lighting which follow.

Backlighting: a slightly different way of doing the same thing is for the photographer to move round until the subject is backlit. The camera will now be facing the sun so a good lens hood is needed—or somebody else could keep the sun out of the lens by casting a shadow on it with his hand. (This assumes that the sun is not so low as to be actually in the picture—if it is, it will cause severe flare, unless part of the subject can be manoeuvered in front of the sun to block it out.)

Now that the direct sunlight is only lighting the very edges of the subject,

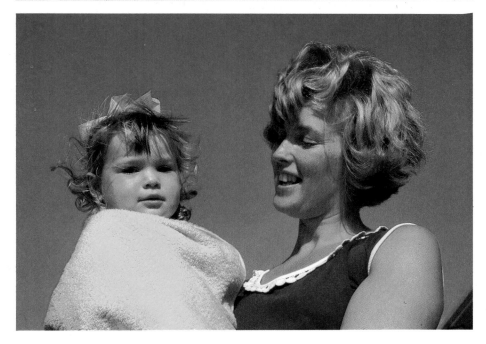

the faces and bodies are being lit only by reflected light from the surroundings or the sky. This is large source lighting. It is almost certainly not as bright as the primary (direct sun) light, so on a camera with adjustable settings the aperture should be opened up by about two stops.

The combination of small source back lighting and large source front lighting is extremely flattering—it makes almost any subject look angelic and idealized. The power of lighting is such that, by moving no more than a metre and using a wider aperture, a sweat-covered, red-nosed, line-ridden man and cross-looking children can be changed to a Greek god and cherubs.

Changing the picture

Instead of changing over from small source light to light from a larger source, the picture can be changed to suit the lighting characteristics.

In the example of the family on the beach, the photographer could move so that the sun is behind her. The subjects will then be more frontally lit, and the effects of the hard, sharp shadows reduced. (Care should be taken that the photographer's shadow does not obtrude into the picture area.)

The faces are now entirely in the lit area and are not so broken up as they would be with side lighting. Any stress lines will be there, but not so obviously. However, any sweat or redness of the

▼ **Right: creative use of strong directional lighting; without the strong shadows this picture would be very dull indeed.** *Jack Taylor*

▼ **Strong side lighting clearly defines the fluting on the columns and the cast shadows add interest to the bare space between the rows of columns.**

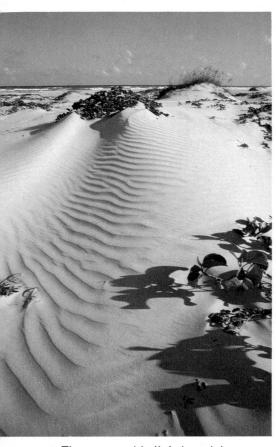

▲ The strong side lighting picks up every detail—the shallow ripples in the sand, individual blades of grass. Notice how the photographer has carefully chosen a position where the grass is shown against the sky. *Jack Taylor*

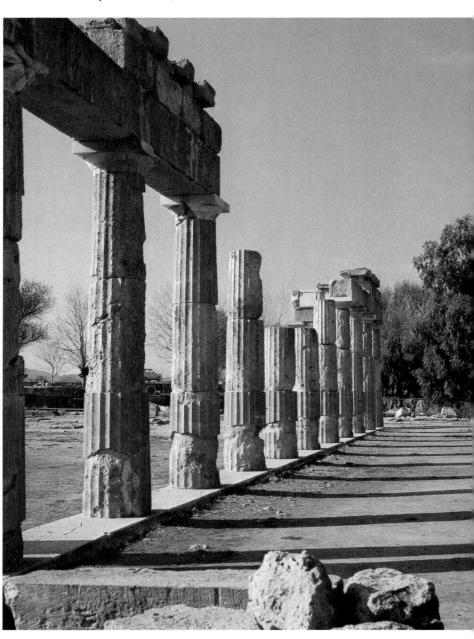

nose will still show up. One solution to these problems is to resort to a soft-focus filter to smooth everything out.

The cruel shadows of side lighting can be lessened by lowering the lighting contrast. Any white or pale coloured material (except green or blue) can be used to reflect some light back into the shadows. This will make the lighting less stark. Reflectors often occur naturally, even within the picture area. For example, a hand or book may reflect light back into a face. This reflected light can even take over and become the principal lighting for a sizeable part of the picture.

Because small source lighting complicates a subject with shadow and revealing detail, the photographer can respond by simplifying the picture. You could try a more formal arrangement. And watch for irritating flaws: untidy hair, creases, and so on. Clean, flat surfaces, or elements such as the sky, can be brought into the picture instead of the complicated beach scene. Finally, take cast shadows into account. The cast shadows with small source lighting are hard-edged and so, unless they are filled in by other light, they show up very strongly in the picture— sometimes even more strongly than the object which casts the shadow. While this can be an advantage in some situations, in an already complex picture the hard-edged shadows may be an unwanted extra element.

Unwanted shadows

Getting rid of shadows is not very easy. Still-life photographers often use a second lamp, but this produces its own, albeit weaker, shadow. They then move the second light to the front so that its shadow is hidden behind the subject, and in the edge of the existing shadow. But this in its turn produces a second set of highlights.

On the beach the problem is probably most satisfactorily solved by lowering the camera angle and shooting up slightly, so that the shadows on the ground are no longer in the picture. As the top half of most scenes is usually much simpler than the bottom half, this immediately simplifies the photograph. There are now no important shadow areas in the picture so it is a good idea to close down the aperture by about half a stop to improve colour saturation in the blue sky.

Using shadows creatively

The hard-edged shadows cast by small source lighting can be used to indicate the shape of another object which the shadow falls across. For example, the shadow of a telegraph pole on the snow dips and rises as it runs across a ditch. The shadows cast by clouds often define the shape of a hill.

Shadows can also have a symbolic effect and can be used to create photographs with a deeper level of meaning and mood. They can give a menacing, sinister effect—for instance, the strong shadow following a lone figure.

Cast shadows can also be very important in the composition of a picture, being used to form patterns and balance or offset the subject matter.

To sum up

Small source lighting will produce a:

Small highlight: results in good colour saturation but gives no shiny-object modelling.

Hard shadow edge: gives good texture visibility but may give little matt-object modelling.

Hard-edged cast shadow: can be used creatively but can complicate a picture.

So while small source lighting works very well in some situations, in many others it needs imagination and know-how to quieten it down and make it work in the way you want it to.

Large source lighting

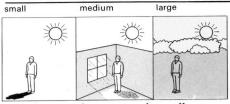

small medium large

The last section covered small source lighting. At the opposite end of the scale is large source lighting where the effective light source is so large or close that it practically surrounds the subject. Light comes from almost every direction, and there are hardly any cast shadows at all.

The most commonly found large light source is an overcast sky. Buildings, such as supermarkets, with white ceilings and rows of fluorescent tubes provide large light sources. When flash is bounced off the ceiling it is often a large light source. A large light source

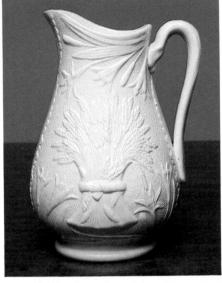

does not need to be bright. The test is, does the lighting cast shadows? With large source lighting the only cast shadows are from objects relatively close to the ground or other surfaces, and even these are very soft-edged.

What it does

Large source lighting tends to simplify a subject. Highlights spread out, often until they are invisible, and this desaturates the colour and markings of the subject. This happens because

◄ Large source lighting produces a spread-out highlight and few shadows. *Malkolm Warrington*

▼ A busy scene with patches of strong colour makes an ideal subject for large source lighting. *Richard Greenhill*

the highlight normally carries the colour of the light source rather than that of the subject, so if a large highlight spreads out through the lit area it will weaken the colour.

The great advantage of large source lighting is its simplicity and unifying effect. It may not help the subject to stand out well but, on the other hand, it does not carve it up as small source lighting can. So, though colour may be toned down, it often shows up well nevertheless, because it has less visual activity to compete with.

Shiny objects: we have already seen how the edge of the highlight can be used to define the shape of shiny objects. When the highlight spreads out the edge is weakened and, unless the object is of a dark colour, may be lost altogether. So large source lighting cannot generally be used in this way, though studio photographers do use a patchy or uneven large source to light shiny objects; this is, however, a rare and more specialized usage.

Matt objects: in the case of matt objects it is the edge of the shadow which gives modelling and texture. With large source lighting this edge is soft and gradual; the lit area slowly changes into shadow area but never quite becomes total shadow.

For this reason, large source lighting gives extremely subtle modelling—so subtle that it is often ineffective. Texture, too, is virtually invisible.

Using large source lighting

While a small source can be turned into a larger source, the reverse process is more difficult. Occasionally it is possible to get a medium source from large source lighting but, on the whole, the photographer has to learn to live with it and turn it to advantage where possible. For example, suppose a photographer visiting a famous city wants to take some pictures of his family seeing the sights on an overcast day. What should he do?

Fortunately for the photographer, large source lighting from an overcast sky is usually easier to handle than small source, direct sunlight. All he needs to worry about is that he does not under-expose the picture, and that there is something in the composition to keep the colours lively.

Exposure for overcast sky

On a cloudy day the whole sky is the light source: though it may not look bright, there is unlikely to be anything around that is brighter. So the slice of cloudy sky at the top of the picture is deceptive and, if the camera has a built-in meter, this bright area will influence the reading; the camera 'thinks' the subject is much brighter than it really is so the sky comes out perfectly exposed but the rest of the picture is far too dark.

To get a correct exposure, take a reading by pointing the camera downwards to cut out some of the sky.

With a fully automatic camera, unless it has a memory lock, the only way to cope with this problem is to set the film-speed indicator half the actual ASA speed of the film being used.

With a simple camera the problem does not arise in the first place—just set it to 'cloudy' and all will be well.

Livening up the picture

Colour contrast: you can compensate for desaturated colours by adding a touch of very bright colour. For example, it would help if the sight-seeing family put on their brightest clothes. Although the colours would be toned down a bit, if they are bright enough there should be plenty left—certainly enough to bring life to an otherwise colourless picture. Even if these colours only form a small part of the composition—a bright coat, for example—the picture has greater colour contrast as a result.

Lighting contrast is likely to be low as well. Small and medium source lighting can be of any contrast, but large source lighting is nearly always of low contrast. Some ingenuity may be needed to increase this contrast; it will, of

▼ **Contrast is increased by including the veiled sun in the picture. Taking a reading from the ground in front of you makes the tree record as a mid tone.** *Richard Tucker*

▼ **Large source lighting reduces the three-dimensional effect of an image and emphasizes the outlines of the shapes in the composition. Slight under-exposure brings out the rich tones.** *John Garrett*

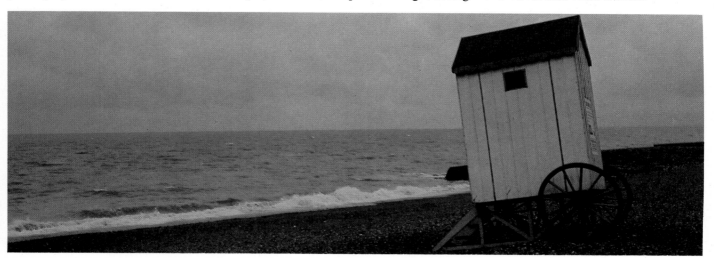

course, depend on the particular situation.

The lighting on a large building is beyond the photographer's control, but if the family were grouped in the foreground quite near to another large building, or solid mass, this would at least cut off some of the light falling on them from one side, so increasing the lighting contrast. They would now be more or less lit by medium source lighting which would give the picture a tonal boost.

Subject contrast: increasing the subject contrast (that is, the tonal contrast of the subject itself, regardless of lighting) has a similar effect. For example, put a light-skinned person in light coloured clothes against a contrasting background such as a dark archway or entrance, and vice versa. Or include a bright light, such as a street lamp, car headlamp or some bright reflection, in the picture to extend the overall contrast. If it is in the background it will give a feeling of depth. It might even give a bit of back lighting to the main subject.

If the sun is dimly visible you could include it in the picture, either by choosing a suitable camera angle or by using its reflection in a window,

▲ Here the soft lighting suits the complex subject matter and several elements are combined to produce this lively photograph. Apart from the bright colour and strong subject contrast, notice how the large clump of trees cuts off some of the available light, so increasing the overall lighting contrast.
Ron Boardman

▶ Overhead fluorescent lighting, such as one finds in shops or offices, produces the typical shadowless image of large source lighting. Fluorescent lighting often produces a greenish tint and a strong magenta filter —CC20 or 30—is recommended. *John Bulmer*

puddle or other shiny surface. And, remember, shiny objects are usually more lively than matt objects as highlights increase the brightness range, so look out for shiny, wet surroundings, too.

Complexity. While complexity is a problem with small source lighting, it can be a positive asset with dull, large source lighting, and the answer to livening up the picture may be to make the composition as busy as possible.

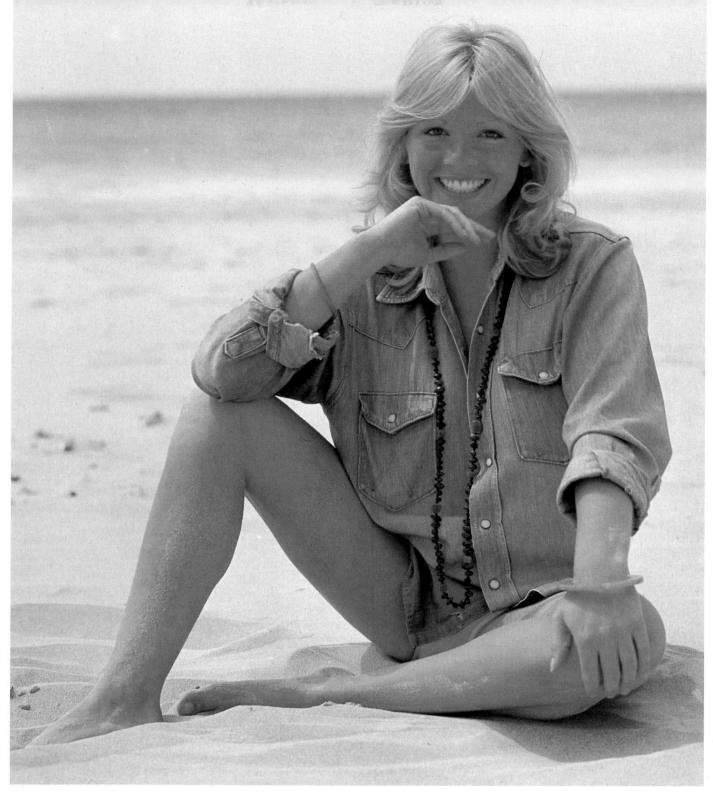

▲ By placing the sun behind the girl, her face is lit by light reflected from the white sand all round her. The shadowless, large source frontal lighting produces a flawless complexion, noses melt away and attention is drawn to contrasting features like eyes, eyebrows and mouth. The light reading should be taken close up from a mid tone such as a shaded part of the shirt.

Other large sources

Fluorescent lighting is often large source and the same general principles apply. Bounce flash off the ceiling may produce a similar effect, but here you have a chance to act directly on the lighting. Turning the flash unit, or in some cases the flash head, on its side and bouncing light off the walls, usually changes the lighting to medium source (the use of flash is covered more fully later in the book).

The angle of the light

Top lighting: an overcast sky or overhead fluorescent lighting produces the problems of top lighting—see section on positioning the light for details.
Front lighting: if you are aiming to make your sitter's complexion flawless this is the lighting to choose. Texture and modelling are not wanted here. Spots and wrinkles are smoothed away as if by magic, noses lose their prominence; only colour and tonal diff-

erences remain—the eyebrows, lashes, pupils, nostrils and lips. This is the sort of lighting achieved by obscuring direct sunlight with, say, a hat.

If the sky is the main light source the picture is likely to have a bluish cast, but on a pale-coloured beach the sand should reflect enough yellowish light to balance this.

Sunlight filling a courtyard can have a similar effect. If the subject is placed in the shade the main light source is the sunlit walls and ground. This light can be strikingly beautiful, especially if the walls are a warm colour.

To sum up

Large source lighting has a:

Large highlight: sometimes useful to show the shape of shiny objects, but will not show up well enough unless object is very shiny and dark in colour. The large highlight obscures the colour of the lit area, producing desaturation.

Very soft-edged shadow area: keeps the subject simple. Produces very delicate modelling. Does not compete with colour or markings. Does not pick up texture. Produces low lighting contrast.

Very soft cast shadows: the cast shadows are so soft-edged that they almost cease to exist. They cannot complicate the picture, but nor can they be used to add contrast. In general, the problem with large source lighting is livening it up.

▲ Large source lighting in the shadow of a courtyard on a bright sunny day. *John Bulmer*

▶ Soft lighting flattens the forms and draws attention to the outline of the subject, giving it an unreal cut-out quality. This effect is heightened by the background being out of focus.

◄ A bright light provides contrast and becomes the focal point of the photograph. *Richard Greenhill*

▼ Soft lighting, with its spread-out highlights, tends to desaturate colour, producing in this instance a monotone effect. *Suzanne Hill*

▼ Bottom: spots of colour again used effectively to lift a picture. If you cover up the splashes of pink, this charming scene of a country rose garden becomes dull and lifeless. Care should be taken not to under-expose in these lighting conditions and a light reading should be taken by pointing the meter downwards.

Medium source lighting

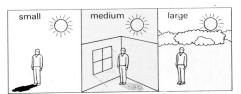

Medium source lighting is something of a universal remedy for most lighting problems, because it is suitable for the majority of subjects and requirements. It combines some of the virtues of small source lighting (texture and good colour saturation) with some of the virtues of large source lighting (relative simplicity). It also gives excellent modelling for shape, as well as a sense of depth, scale and solidity.

Though some very simple, or small, or pale-coloured, objects need the strength of small source lighting, and some very complex subjects need the simplicity of a large source, medium source lighting can cope with most situations.

What is medium source?

A whole range of lighting lies between large and small light sources, but for the sake of simplicity only one inter-mediate size is considered here: one which is midway between the two ex-tremes in effect. A medium light source can be recognized by its soft-edged shadow area. Though, unlike large source shadows, the shadows are substantial, they do not have the hard edge of small source lighting.

The definition of a medium source is lighting where the size of the source is very roughly as great as its distance from the subject. For example, a window 2 metres across and 2 metres away from the subject would fit the definition precisely (so long as no direct sun hits the subject); in fact, it could still be called a medium light source at any distance up to about 4 metres.

A reflection, or a patch of sunlight on a wall, would be medium source if it was roughly as big across as it was far from the subject.

What it does

Medium source lighting gives excellent modelling for shape and roundness. The highlights are large but are usually definite enough to be clearly seen. Although there is more colour desat-uration than with small source lighting, it is not extreme, as the highlight is not so large as to obscure the lit area.

Medium source and shiny objects: if the subject has any shininess at all the well-shaped highlight can give a pleasant and sensuous appearance of roundness to it. Shape and surface information come across well.

Medium source and matt objects: the shadow/lit area border, which is so important in communicating shape and texture, is well-defined and yet gradual. With small source lighting this area is too abrupt and narrow to give much description of shape, and with large source it is too subtle and vague. Medium source is ideal lighting for matt objects. The graduation of tones from lit area to shadow gives tactile shape and texture to each element of a picture. Unlike the over-subtle transition of large source lighting which never quite reaches shadow, the shadow from medium source can, if there is no fill-in lighting, go right into blackness.

Outdoor medium source

Unfortunately, medium source lighting is not very common out of doors; if the sun is shining brightly it produces small source lighting; when it is cloudy the lighting is usually large source. But medium source lighting does occasion-ally occur out of doors: when a black and thundery sky folds back a little to allow a brilliant sunlit cloud to act as a medium light source, for example. The cloud acts as a giant floating reflector.

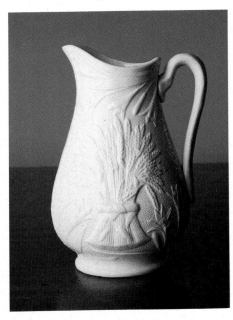

▲ Medium source lighting gives good modelling for shape. Note the distinct but soft-edged shadows and compare with photographs on pages 20 and 26. *Malkolm Warrington*

▶ The medium source in this picture is the open doorway. The shadows are the soft ones characteristic of medium-source lighting, and the white walls reflect light which lightens the shadows further. *Anthony Blake* took three exposures, bracketed at one stop intervals (shutter speeds of 1/15, 1/8 and 1/4) to ensure that he got a picture with the best possible balance, retaining detail in both the highlight areas and shadows.

(This lighting should not be confused with the effect of sunshine coming *through* slight cloud or mist, which is actually a combination of small source and large source light.) If you want to use medium source lighting outside you usually have to create it or look hard to find it. You may find it in the shadows, especially on a sunny day.

Changing small source to medium: look for a situation where the direct sunlight is blocked, so that the subject is in cast shadow, and where some light-coloured surface is acting as a reflector.

Alternatively, it may be possible to block the sunlight by using a beach umbrella, hat or similar object (see earlier).

The result will not necessarily be medium source: if light is coming from the sky and surroundings, rather than from one main direction, the lighting is large source; but if a light-coloured surface reflects light on to the subject so that it is directional, with soft-edged shadows, then you have medium source lighting.

You may find that only a small area within a potential photograph is lit by medium source lighting. The overall scene is lit by small source light, perhaps from the back or side, but an area—a face, perhaps—is in shadow and lit by light reflected back from a surface such as a hand or a book. You can produce very romantic lighting by over-exposing a picture of this sort. The area lit by direct, small source light becomes burnt-out white, while the face, lit by medium source, is correctly exposed.

Changing large source to medium: large source lighting from an overcast sky can sometimes be changed to medium source by using large objects such as buildings or trees to reduce the size of the light source (see earlier).

Indoor medium source

Here the *level* of lighting brightness is often a problem—there isn't enough to

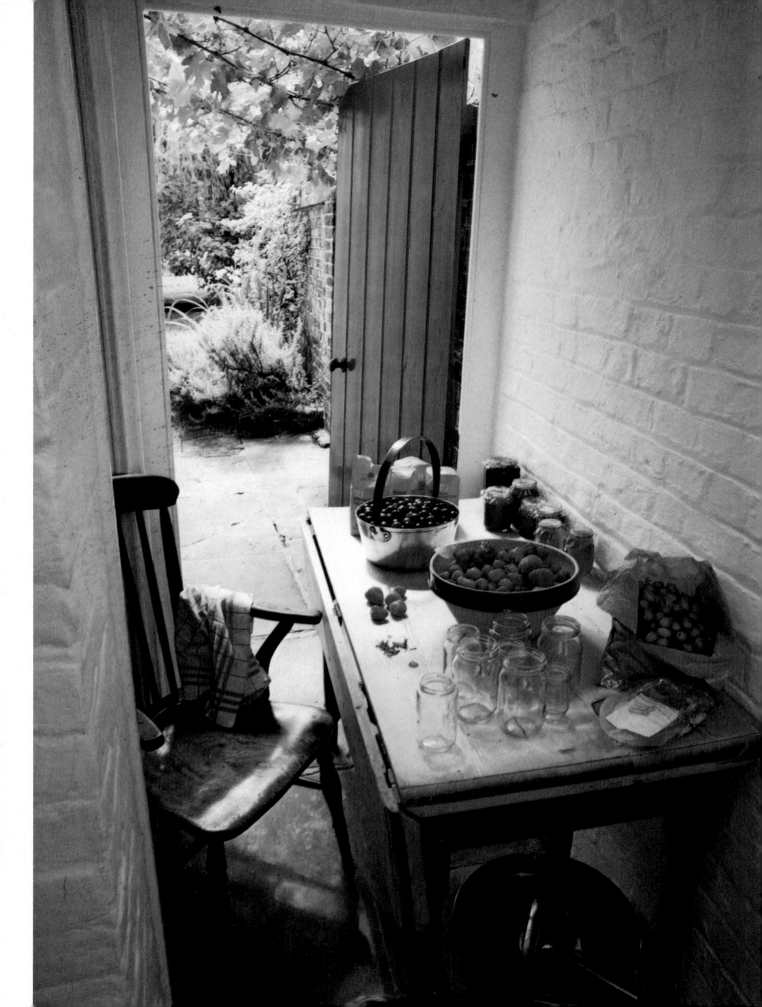

give a short exposure or much depth of field. But this is often more than compensated for by the *quality,* which can be marvellous. This is particularly true of daylight coming through a window.

Natural lighting: light coming through a window, provided it isn't shining directly into the window is usually medium source. (The exception is a tiny window, very far away, which might fall into the category of small source.)

The light coming from the sky will tend to have a bluish cast and it is a good idea to use an 81A filter to compensate for this.

Contrast is sometimes rather high. You could remedy this by using a bounced flash, or you could use a reflector to lighten shadows. But this is only practicable for small set-ups such as portraits. Even if the reflector does not seem to have a very great effect, it can prevent the shadows from becoming completely black. Another way to lower contrast is to open a door, or pull back some curtains to allow light in from a different direction. It all helps.

If sun is shining into a room and striking a white wall the patch of light created is medium source. Its colour will usually be slightly warm or golden. But remember that if the direct sunlight strikes a strongly coloured surface, it is liable to give the picture an overall cast of that colour. To avoid this, position a white sheet or piece of paper or newspaper in the patch of light to act as a reflector.

Direct sunlight coming through a window can be changed to medium source by fixing a diffuser, such as tracing paper, over the window. A white roller-blind or fine net curtains *may* give the same effect, or they may allow some direct, small source sunlight through—it depends on the fabric. If this happens, a combination lighting similar to that produced by hazy cloud or mist is produced. To find out if the lighting is medium source or combination, look at the cast shadows. If they are sharp-edged, though pale, the lighting is combination. If they are soft-edged it is medium source.

Artificial lighting: medium source lighting is not often provided by lighting indoors, except under studio conditions. In fact, in the past 15 years or so photographers have tended more and more to use medium source and have a battery of equipment to produce it, like special white or silver umbrellas and large box-lights covered with dif-

fusers. Strip lighting is usually large source, and most tungsten lighting tends to be small source or a combination lighting.

Some large lampshades do give medium source lighting, as do lamps which are designed to bounce light off a wall. But with these sources you need a fast film, or to use a large aperture, or a slow shutter speed with a tripod. Colour transparency film needs to be tungsten type to avoid an orange colour cast.

Bounce flash can produce medium source lighting and, as it does not require special film, large apertures or long exposure times, it is often the most practical solution.

Some flash units come with a bounce board which can be attached to the flash head. Although this gives some variation from the small source frontal lighting produced by direct flash on the camera, it is not nearly big enough to give the quality of medium source lighting, unless the subject is within a metre of the flash. A better solution is to fix up, or ask someone to hold, a larger reflector such as a sheet of newspaper and bounce the flash off this.

It has been suggested that putting a handkerchief or paper tissues over the

flash will give a softer result. This will diffuse the flash and contrast may be reduced. But this method does not make the source any bigger; it does not create medium or large source lighting and in fact it may do nothing except cut down the power of the flash.

To sum up

Medium-sized highlights: ideal for showing shape of shiny objects. Not so much loss of colour through desaturation as large source but more than small source. If colour saturation is paramount, a smaller source may be necessary.

Moderately soft edge to shadow area: produces full, rounded, deep modelling on matt objects. Reasonably good texture, but not as strong as with small source. Where texture is paramount, a smaller source may be necessary. Conversely, for very complex subjects, or to subdue texture, a larger source may be best.

Soft-edged cast shadows: give a good sense of the mass and scale and depth of the elements of the picture but do not compete with the subject matter.

Conclusion: one cannot usually go wrong using medium source lighting.

▲ If you look at the wooden egg you can see how the full range of tones and soft shadow edge of the medium source lighting convey the form of the object. *Michael Boys*

▶ The shadows show the nature of the light source. Although these are pale they have a very distinct edge and the lighting is a combination of small and large source from the sun and cloudy sky.

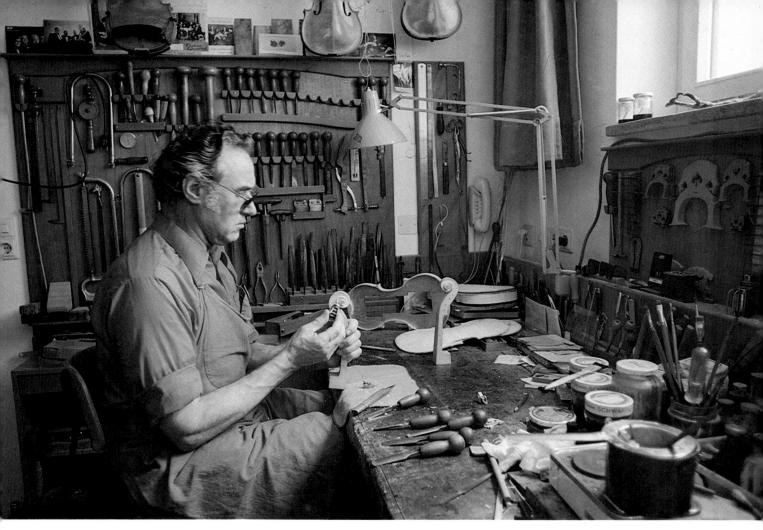

▲ *Richard Greenhill* diffused direct sun by putting tracing paper over the window. In a similar situation, remember not to include the window area when you calculate exposure as the photograph will be underexposed.

▼ Medium source lighting coming through a window on the left produces high contrast even though some light is reflected back into the shadows. Take an average reading for the exposure with this type of shot. *Clay Perry*

Photographing into the light

For most of us, the first piece of photographic advice we hear is to keep the sun behind our left shoulder. This is to ensure reasonable modelling, to keep exposure determination simple and to avoid the pitfalls caused by including the light source in the picture. However, if photographs could be made simply by following the book of rules there would either be no great photographs or all of our pictures would be masterpieces.

Edward Steichen said that there were only two problems to be solved in photography, to capture the right moment of reality as you release the shutter, and to conquer light. One step towards the latter is to disregard the rules occasionally and to take your pictures facing towards the light rather than away from it.

Shooting into the sun

A photograph taken into the sun, called *contre-jour* by Henri Cartier-Bresson, makes the subject stand out against large areas of shadow and this in turn creates a greater feeling of depth and richness of tone, particularly in colour work. For example, a picture of trees and flowers taken against the light has a high colour saturation because the amount of white light reflected from the surfaces of the leaves and petals is reduced to a minimum. With light at normal angles the surface reflection of white light is far greater and the colours become desaturated.

Working with colour film out-of-doors, however, while giving us greater freedom, also brings more problems to solve. Daylight colour film is balanced for average 'over the shoulder' lighting and this is usually expected to be sunshine with small white clouds in a blue sky. Where the sunlight falls the light will be apparently normal and in the shadows light reflected from the blue sky by more or less cloud will show as more or less blue.

Photographing into the sun, therefore, means that we are exposing all the shadowed areas by predominantly blue light. Our eyes will adapt and try to correct this blueness—the film will not, and some form of filter must be used to compensate. A skylight filter is ideal for this purpose, its pinkish hue warming the shadow colour to the point where we will accept it as being correct.

Starburst filters

When a small point of light source is included in the picture you may find

▼ By shooting into the light, the main subject can be made to stand out in bold contrast to the areas of shadow in the foreground. *Homer Sykes*

◄ The light in this shot is in front of the camera but slightly to one side of the family group. This creates a kind of rim lighting on the right-hand side of the figures and also gives greater detail than if the sun had been directly in front. Notice how the film has recorded the much bluer light of the shadowy area in the foreground of the picture. *John Garrett*

► The rich, saturated green of the leaves in this picture could only have been achieved by shooting into the light. By doing so the light is transmitted through the translucent leaves, rather than reflected from the surface as it would have been with the more conventional over-the-shoulder lighting. To keep the colours deep and to prevent the over-exposure that would have resulted from a reading taken from the bright burst of light, *Timothy Beddow* used a very small aperture (f22) and a fast shutter speed.

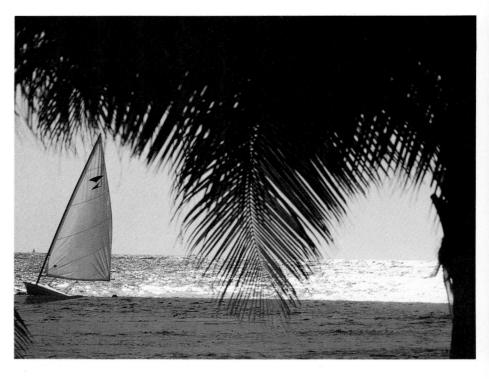

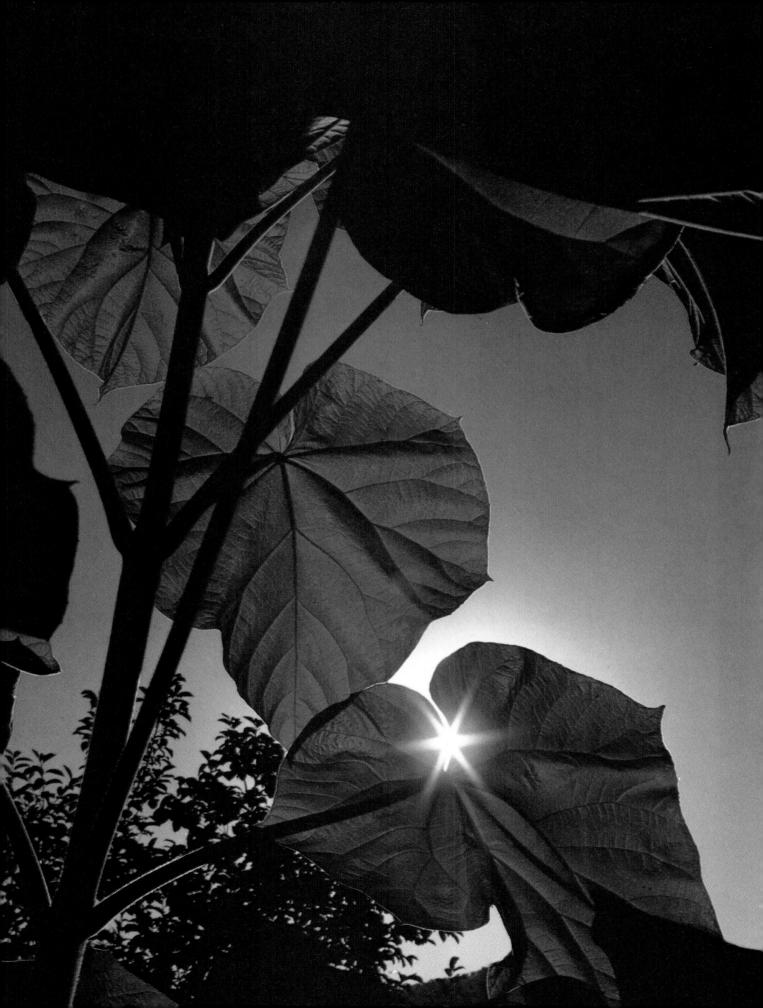

that as well as the ghost diaphragm shapes there are lines of light radiating from them. It is possible to turn this defect to advantage with the starburst filters currently available. These comprise fine lines in a square pattern, etched or moulded on to a clear piece of glass. Their function is to exaggerate the radiating lines from lens flare. They also diffract the light into bright rainbow colours and produce beautiful and dramatic emphasis on backlit subjects with many small highlights. Ripples on water or speckles of light through leaves are ideal subjects to photograph with starburst filters.

Determining exposure

With conventional backlighting one of the biggest problems is calculating ex-posure, especially if the subject is a landscape with a low sun. The meter will respond to the brilliant highlights, which in effect means that it will read the light source and not the subject. The subject will then be heavily under-exposed. A good rule of thumb for many subjects against the light is to give four times the exposure indicated by the general meter reading, but this will depend on the size and importance of the highlight areas in the frame.

Another solution is to measure the exposure from the sky directly above your head. This is the equivalent of a mid-tone in a more conventionally lit subject and should give acceptable detail in the shadow areas. Once again, bracketing the exposure will increase the chances of a perfect result.

Interiors

For pictures taken indoors the photographer can exercise a considerable degree of control over the light source and can use the technique of shooting into the light to achieve a planned result and extend the creative lighting possibilities.

The major problem here is that a back-light behind the subject may spill over into the studio area to grey the shadows or reflect back on to the front of the subject as light of a different colour, having been bounced off the walls behind the camera. For studio flash you can use a snoot, a tube over the source which minimizes spill, but tungsten spotlights will give a similar result with greater control. For small subjects you can prevent light being

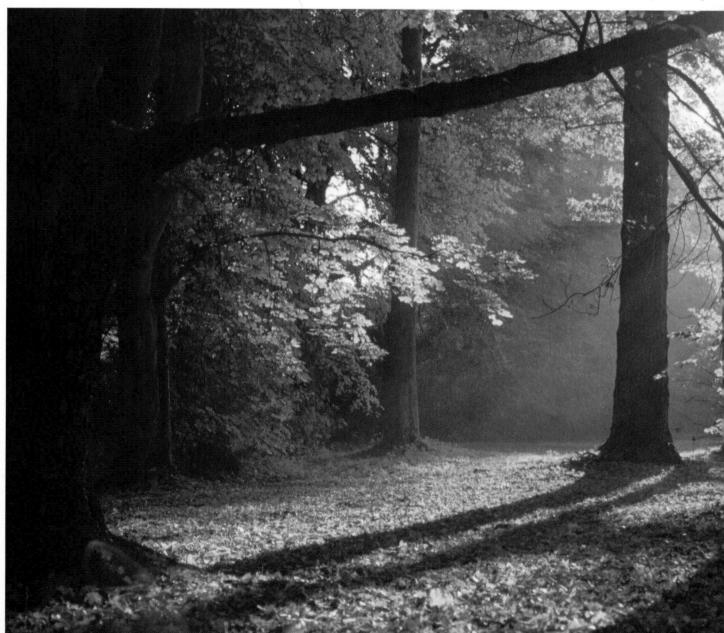

bounced back on to the front by placing a piece of black card upright and below the camera so that it is not included in the picture. For larger subjects the wall behind the camera should be blacked off.

Backlighting in the studio need not always be harsh or with hard-edged shadows. A large source, such as an umbrella flash or a large reflector, can be used to give the richness of unlit shadow areas, with the tonal quality that comes with soft lighting.

So, although it does present its own problems these can be overcome, and being courageous enough to break the rule of not shooting into the light should reward you with some outstanding pictures or, at the very least, some interesting effects.

▲ If the light is just outside the picture area, it is possible to prevent flare from stray light by casting a shadow over the lens with your hand (top). However, as *Michael Busselle* shows above, including some flare can add to the picture.

Lens flare

When a light shines directly into a lens it not only forms the image but scatters generally between the various glass surfaces, creating fogging and lack of contrast. It also creates 'ghost' diaphragm shapes of different sizes and colours. These are superimposed on to the image and known as lens flare.

This problem has become more acute with the increase in complexity of lenses. The effect is most often found with zoom lenses which can have as many as sixteen component glasses and up to a dozen surfaces, some elements being cemented together.

To see what the effect of flare may be, point an SLR towards (not at) the setting sun. Sometimes *including* limited flare can add to a picture. Fit a lens hood or shade the lens with your hand (just out of shot) if you want to modify the effect. If you are using a modern lens the effect will be reduced anyway, as multi-coating is now a feature and this greatly minimizes the effects of light scatter.

◄ The full effect of the sun in this picture has been reduced by the trees, but it is still fairly bright. To capture the light shafting into the wood, *Clive Sawyer* took the exposure reading from the lightest part of the scene, although not from the sun itself. Because the subject is naturally high in contrast the slight flare which has resulted serves to add to the picture rather than to spoil it. Had the sun been more obviously in view the exposure would have to have been calculated from that part of the picture farthest from the light.

▶ Working in a studio gives the photographer greater control over the light source. Here, *John Garrett* has combined strong back lighting, to outline the girl's head, with soft front lighting to bring out the detail.

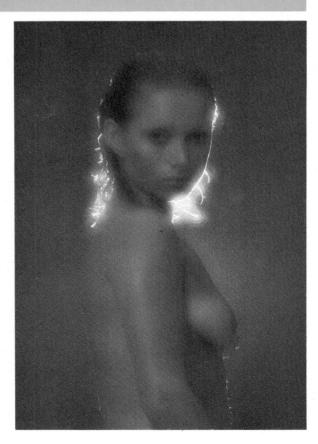

Sunsets

One of the most popular subjects for photographs which include the light source is the sunset. This occurs at any time from two hours before the sun disappears below the horizon until about 30 minutes afterwards. During this time the light drops rapidly, perhaps as quickly as one f stop a minute. You will therefore have to check the exposure every 30 seconds. You will notice when looking at sunsets that as the sun sinks lower in the sky it appears to grow larger and the light it gives gets progressively redder. For these reasons a longer focal length lens will give the most effective representation of the sun and, of course, an extreme telephoto gives those dramatic shots of a huge red ball touching the horizon.

As with most landscapes, foreground objects can be included in sunset pictures to great advantage. They should be chosen for their shape in silhouette, as well as for their contribution to the overall scale of the image. A meter reading taken from the sky when the sun is below the horizon will turn backlit forms into silhouettes. Boats on water highlighted by the sunlit sky, trees and recognizable structures such as famous buildings all benefit from the simplification that a sunset silhouette gives, allowing the photographer to concentrate on shape and pattern. Using a wide angle lens has the effect of making the sun smaller and the foreground correspondingly more prominent.

▼ The most spectacular moment in a sunset is often only seconds before the sun disappears below the horizon. It is well worth waiting for. *Timothy Beddow*

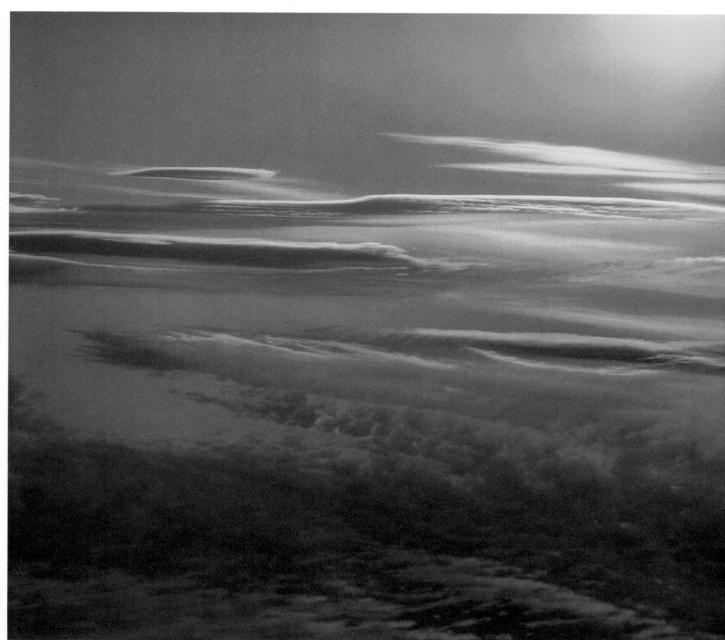

► This picture includes two elements of composition, either of which can turn a rather ordinary sunset into an extraordinary photograph—a dramatic silhouette and a reflection of the sun in the foreground. *David R. MacAlpine*

Below right: as the sun sinks in the sky it seems to become larger. One of the most effective ways to capture this in a photograph is to use a fairly long focus lens. If the sun is also thrown slightly out of focus, as it is here, the lack of a sharp outline will make it appear bigger still. *Alexander Low*

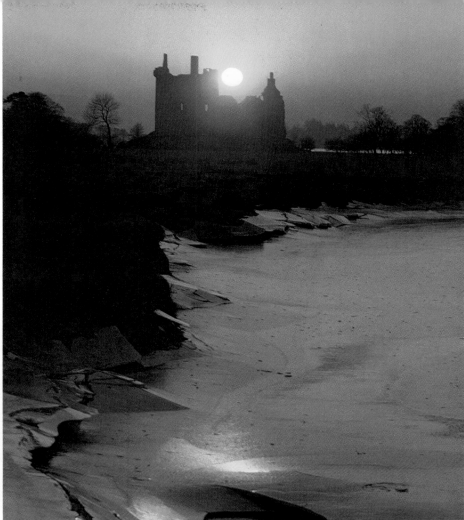

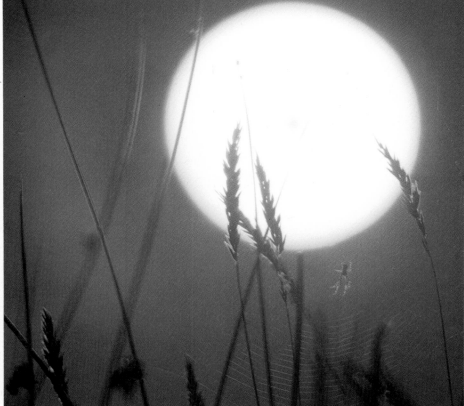

How to use sidelighting

Although traditional over-the-shoulder lighting may seem to be a universal recipe for good photography, it has already been seen that several other lighting angles can often give more impressive results.

The case against over-the-shoulder lighting is that it produces a flattened effect, doing nothing to bring out detail or provide an impression of depth. The eyes see in three dimensions, and can compensate for unhelpful lighting. But a photograph is two dimensional. To give an impression of the form, depth and texture of the subject, the light should ideally come from the side, or at least at an angle.

Lighting angles

Look carefully at an ordinary brick wall. First in direct light and then in side-lighting. Direct light will show the pattern of the bricks and mortar in a flat, uninformative way. But side-lighting will create shadows in every little crevice.

The effect increases the more the light is angled in line with the wall, until long shadows fall from the smallest irregularity in the brickwork. This can give an almost three-dimensional effect to a photograph.

Sidelighting is particularly important with black and white photography, which relies on a tonal range rather than colour to record the subject. Shadows from sidelighting reveal details. These can create striking pictures from all manner of ordinary objects which otherwise would be scarcely worth photographing in black and white. Anything which has a noticeable texture—like the ripples of sand on a beach, for example—gains impact when lit from the side. Land-

scapes, buildings, people all look better when sidelit.

All this goes for colour photography too. Colour gives the viewer extra information about the subject which may make up for a lack of texture in frontal lighting, but often the result is livelier with the light from the side.

Using artificial light

Sidelighting is suitable for most still life and close-up subjects. The textures of flowers and fruit, or of embroidery all show up best with sidelight.

Taking your subject indoors, you can

◀ With the 'sun over the shoulder' technique, this shot would have been reduced to a two-dimensional pattern, losing the texture of the wall and the prominence of the window frame. With the light from the side, *Helen Katkov* was able to show the subject as more three-dimensional.

▶ *Michael Burgess* took this shot from directly above the subject. Midday sunshine would have minimised the shadows, directing them downwards. The low afternoon light throws longer shadows that show up the texture and add interest to the picture.

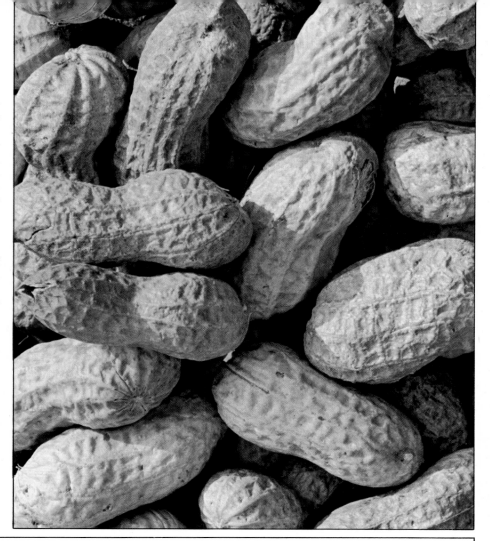

SIDELIGHTING FOR TEXTURE

To demonstrate how strong sidelighting picks out detail in a subject, *Malcolm Warrington* positioned a direct light source at three angles to a spool of string, keeping the camera angle the same each time.

(A) The first shot shows the effect of overhead lighting. With little detail, the subject appears like a two-dimensional rectangle on an even surface.
(B) The second shot was taken with the light at 45° angle. Though the detail is slightly more distinct, the background still looks quite smooth.
(C) With the light on a level with the subject and to the side, detail is very strong. The greater area of shadow makes the subject seem a darker colour and reveals the texture of the slate background.

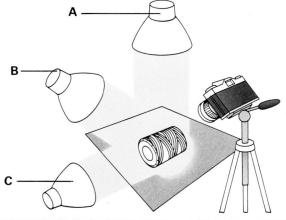

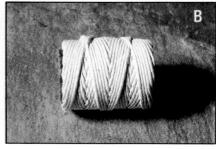

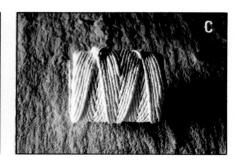

either set up photofloods to light it or use your flash gun off-camera with an extension lead. You can use an ordinary tungsten light as a modelling light. Angle it until the shadows show the strongest detail in your subject, then place the flash in the same position. With flash, extreme sidelighting can give too much contrast, as the light comes from a concentrated source. Contrast can be controlled
(i) by moving the flash further from the subject; and
(ii) by adding a piece of white card to act as a fill-in reflector.
If you make notes of the set-ups you use, you will soon learn how to control sidelighting indoors.

Using daylight

All lighting from a small source is directional: if it comes from a lamp or a flash gun you can control the angle at which it strikes the subject. But you cannot control the light from the sun, except by choosing the best time of day (or time of year) for your subject.

When asked to photograph a mansion, for example, a professional will work out the most suitable time of the day for each aspect, and wait until the lighting conditions are right. Few people, however, can afford to wait for this kind of perfection, but an understanding of how lights affects any subject will help you to get better results.

The best times of day for sidelighting are early morning and from mid-afternoon onwards. The lower the sun in the sky, the more angled the shadows on your subject—as long as the light is shining from the side.

In winter the sun travels in its lowest arc across the sky so that a sunny winter's day may give sidelight for longer, depending on latitude.

In the spring and autumn the sun's light

▶ Though the strong colour is the most striking feature of this shot, the deep shadows also contribute to the image by providing contrast. They give the picture depth, too, by rounding the sides of the buckets. *Ed Buziak*

▼ This almost monochromatic shot would hardly have been worth taking without the low sidelight which etches in the detail. A lens hood does little to stop flare with a wide lens: *Patrick Thurston* shaded the lens with his hand.

▶ Like those of a landscape, the contours of the human body are all the more distinct when lit from an angle. *John Garrett* used a black velvet background here to absorb any stray light and lit the shot from the side.

is flattering to many subjects for long periods, though in the middle of the day it will be too high to create the long, angled shadows that produce really sparkling photographs.

The sun is least useful for sidelighting in the middle hours of a summer's day. At its zenith, the sun pours down bright, harsh light which gives dense, downward pointing shadows that flatten the landscape and buildings. Colour enthusiasts will be tempted by the saturated colours, but perhaps disappointed in the lack of modelling and texture.

By waiting until later in the day, you will find that a country landscape will take on a quite different appearance: low sidelighting will etch in the lines of the subject, strike long shadows from grazing sheep and cattle or show the textures in a mud track engraved with the tread of tractor wheels.

Technical problems

There are few technical problems involved in using sidelighting outdoors. First, it is wise to use a lens hood to protect the lens from flare which will degrade the image. Second, colour photographs taken in sunlight early or late in the day will take on a yellowish cast. This often adds to the quality of the picture. But if you prefer to eliminate it, fit a blue 82A filter to your lens. This will balance the colour temperature of the light to the colour temperature of your film.

To improve black and white landscapes, use an orange filter to emphasize the textural effects on brickwork, timber and ploughed earth. Use a red filter for even stronger effects. With architectural subjects, this gives dark tones, deep shadows and strongly emphasizes highlights to produce rich, low-key prints. It also darkens blue skies dramatically, and brings out clouds.

For outdoor portraits, sidelighting gives strong modelling on your subject. If the modelling is too strong, however, you may have to use a reflector or fill-in flash to lighten the shadow side of the face. A further advantage with portraits is that with the light coming from the side, people do not have to screw up their eyes, as they often do when the light is coming over your shoulder.

Exposures

With strong sidelighting, the contrast between highlight and shadow areas will be too great for the film to record, so some detail will be lost. Highlight detail will generally be more important than shadow detail—especially when shooting slides. Meter the highlights, then, and expose for them. Dark shadows will go solid black, but this will add to the effect.

To sum up

The shadows formed by light coming from one side of your subject give the picture texture and relief. This is particularly useful in black and white photography where shades of grey are all the viewer has to go on.

With colour photographs too, shadows appear to modify colour on different planes of the subject so that it gains an impression of form and depth.

For any shot which depends on these elements, it pays to have the sun on your side, and not on your back.

▶ This strange still life of three toadstools exaggerates the way that sidelighting actually gives the viewer more information about the subject. From the top you cannot guess how tall each toadstool is: only the shadows give any idea of their relative sizes and shapes. *Eric Hayman*

◀ For portraits, sidelighting will accentuate the bone structure of a face and its most prominent features. It also means that the subject need not screw up his eyes as he would if the sun were shining over the photographer's shoulder. Sidelighting also shows up skin texture. This can be unflattering in portraits of women, but shows 'character' in men. *Lief Ericksen*

▼ Architectural photographers will normally work out the best time of the day to take their pictures, when the light is falling on the side of the building. Glancing light reinforces the pattern of the architecture. *Ed Buziak*

Emphasizing form

Any picture is a way of representing solid, three-dimensional objects on a flat, two-dimensional surface. The impression that the objects have *form*—that is, a shape from front to back rather than simply an outline—is an optical illusion.

What contributes most to this illusion is the play of light and shadow on the subject. Where the surface of the object faces the light source directly it is very bright; where it faces away from the light source it is in dark shadow; where it is at an angle to the light source the effect is in between the two. From this information we can 'read' how the object is formed. Pale shadows that only gradually increase in density indicate gently sloping surfaces and hard edged shadows show a sudden change in direction.

If your aim is to emphasize the form of your subject it is important to keep the lighting simple. More than one light source may throw confusing cross-shadows and disrupt the gradual progression from light areas to dark areas. The two other vital factors in emphasizing form are the angle and the quality of the light.

The quality of the light

The best light to use for emphasizing form is a large, diffused light source. The larger the light source the gentler the progression from light to shade and the more information about the surface of the subject can be gleaned on the way. A harsh, small light source—like a bright midday sun or a narrow spotlight—creates too sudden a change.

With artificial lighting you can control the amount of diffusion relatively simply. Tungsten studio lights can be equipped with a variety of reflectors that tone down the hard edged shadows thrown by a narrow beam of light—from very broad reflectors that give pale shadows with indistinct edges to bell-shaped, open reflectors that have an effect half-way between the two.

Flash light is more difficult to control, though you can buy special diffusers

▲ Lighting is crucial for showing the form of your subject. Low backlighting from the evening sun shows the balloon in outline only. *Rémy Poinot*

▶ With the sun higher in the sky and from the side you can see how each individual panel is formed. *Rémy Poinot*

Far right: the smooth surface of these rocks would have looked flat in overhead light. The setting sun has picked out the undulations of the rocks showing their form. *Lawrence Lawry*

that fit on to the flashgun to soften the shadows it casts. Bouncing the light from your flash gun off a broad white surface like the ceiling or a wall will also soften the quality of the light considerably.

Working by natural daylight, there is little you can do to influence the quality of the light. A light mist, heat haze or a thin covering of high cloud all have the effect of diffusing the bright sunlight for you, and these are the best circumstances under which to emphasize form under natural daylight.

If your subject is quite small you can stretch fine muslin between the subject and the sun: this will have the effect of lightening the areas of shadow and making the details of form visible within them.

Photographing indoors by natural daylight, net curtains or some similar fabric stretched across the window will also soften the shadows, giving a far more subtle idea of the form of your subject than bright, direct beams of light.

The angle of light

The other element crucial in emphasizing form is the angle of the light. You can demonstrate this for yourself quite simply. Place a white mug close to a fairly bright light, like a window or an anglepoise lamp. Walk round to take a look at the mug from the same position as the light source (making sure that your own shadow does not fall on the mug). Viewed from the front, with the light shining directly onto it, the mug appears as a rectangular patch of white, with perhaps only a suggestion of shadow down each of the rounded sides. As you move round it you will see more of this shadow, which will appear to creep gradually around the side of the mug. When you reach a point where the mug is directly

LIGHTING TO EMPHASIZE FORM

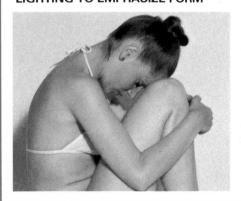

1. Direct flash. Photographing indoors, *Vincent Oliver* used it to light his model from the front (far left). The shadow falls behind her so the areas we see are evenly lit with little modelling, and look flat.
2. Using a reflecting board. Then he bounced the flash light off a reflecting board placed well to the right of the model and slightly in front of her (left). In this picture the well-lit areas change gradually into shadow, clearly showing the roundness of the figure.

between you and the light source, the area you can see will be completely in shadow, once more emphasizing the outline rather than the solid form of the mug.

The same is true of rectangular objects, though the areas of light and shade will be more strongly separated because of the sharper angles of the surface. If you place a square box with one corner directly towards the light source, two of its facets will be lit equally and two will be equally in shadow, making it difficult to determine where the angle of the corner falls.

◀ **The best light to show form is when it falls at 45° to the camera-to-subject axis. Here the girl's back is lit by glancing sunlight while her side is in shadow.** *Andreas Heumann*

▼ **Glossy highlights and deep shadows under the cherries give a strong sense of roundness.** *Sanders*

The best lighting to show form is from the side and slightly to the front (so that it falls on the subject at an angle of 45° to the camera-to-subject axis). This will give a round object rather more highlight than shadow around the surface, but the shadow areas will be sufficient to show the form quite clearly.

Background shadow

Another indication of the solid form of an object is the shadows it casts on the background. Although very strong, angular shadows certainly indicate the position of the subject, they can be very distracting and give a confusing idea of form. And if the light is coming directly from the front so that the object's shadow is completely hidden, it gives a peculiar impression that it is floating on the background rather than in firm contact with it.

Again, the success of background shadows in indicating the form of an object relies on the angle and the quality of the light. A deep pool of shadow around the base which softens gradually into the background makes the object appear to be sitting solidly on its base: for this effect you need a soft diffused light source. If the light is angled from behind the object the shadow will be too dark and too long; if it is angled from the front or from directly above there will be no shadow cast at all to help the impression of form.

When we look at an object in front of us we *know* it is real and solid, with a very definite form. But this is not always clear in a two-dimensional image. Train your eye to notice the way light and shade reveal form, and translate the information into your photograph. If you can't change the lighting, change the position of your subject. If that can't be moved, position yourself so that the light is falling on your subject in the way best calculated to emphasize form.

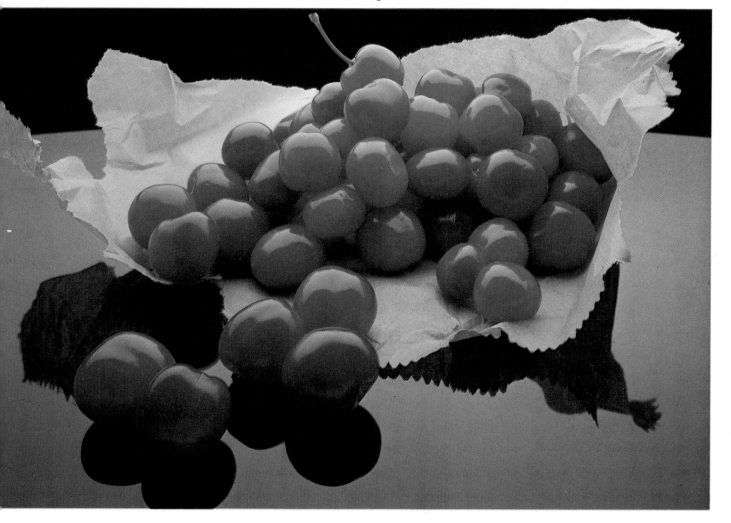

The importance of shadow

Shadow is an important, though often neglected, element of composition. Used carefully and creatively it not only gives a great sense of depth and form but may also provide an additional area of interest to complement the main subject of the picture. The influence of shadow is so strong that it should be considered as carefully as the main subject itself when composing the picture within the viewfinder.

How film registers shadow

The human eye is extremely versatile and has a remarkable ability to cope with an extreme range in the brightness of light. It can see detail both in bright sunlight and in deep shadow. This is called the brightness range and the standard for the human eye is measured as 1000 to 1.

Black and white film, however, has a much smaller brightness range. It cannot compensate for great changes in the brightness of light and only registers detail through a range of 128 to 1. With a good black and white film developed in a standard developer this is equivalent to an exposure latitude of seven f stops.

Colour film has an even smaller brightness range. Slow transparency colour film has a range of only 32 to 1, equivalent to about five f stops.

What all this means, more simply, is that when you are looking at a subject that is unevenly lit you will be able to see detail in both the well illuminated areas (highlights) and the areas of relative darkness (shadows). The film in your camera, however, will not be able to do so, and if you expose for the highlights the shadows will come out very dense and almost totally without detail. If you do the opposite and expose for the shadow areas, then the highlights will be over-exposed and the detail washed out.

There is really no practical way of increasing the brightness range of film but its very limitations can be used to advantage—getting rid of an unwanted background, for example.

Contre-jour

The effect of taking your picture into the light and exposing for the shaded side of your subject is known as *contre-jour*. With the correct exposure you get a soft image with a ring of light, or

◀ These two pictures, both taken with the same exposure, show the difference in the effect of shadow on colour film compared with black and white film. Because colour film is less able to cope with changes in the brightness of light the shadow areas appear darker than those in black and white. Notice the range of tones in the trees in the picture below compared with the lack of detail above. If you are doing your own black and white printing you can to some extent control the contrast, and hence the density of shadow, during processing, but you have to be more careful with the original exposure if you are taking pictures in colour. *Michael Busselle*

▶ To illustrate the difference that exposure can make to the density of shadow and the consequent effect on the overall image, *Ron Boardman* varied the exposure by one f stop for these two shots. The shadows on the girl's face in the picture above are almost black, producing a flat silhouette which emphasizes the outline of the subject. Increasing the exposure for the picture below has given more detail in the shadows and a rounded form to the face and fingers. A similar effect could be achieved by reflecting light on to the face without changing the exposure.

halo effect, around the subject. The background, however, will be heavily over-exposed and will almost disappear.

Calculating exposure

Just what exposure you give your subject depends to a great extent upon the importance that you want shadow to play in the composition. As already explained, if you expose for the highlight areas in an unevenly lit subject the shadows will be under-exposed and lacking in detail. Taking an average of the readings from both highlight and shadow areas should give you acceptable detail throughout.

● It is important to remember that if your final pictures are prints rather than transparencies, you must notify the processor so that he does not 'correct' your exposure.

You may find that when taking light readings from more than one area of a subject a 'spot meter' or hand-held meter is more accurate than using the integrated light meter in your camera. But if you don't have a hand-held

◄ **By shooting towards the light and exposing for the bright background, the under-exposed subject in both these pictures has become a flat, dark shape. In the picture above** *Adam Woolfitt* **has used shadow to emphasize the shape of the clouds and to suppress unwanted detail in the foreground. For the picture below** *Michael Busselle* **chose to place his subject in deep shadow for a simple but dramatic image.**

▶ **An interesting shadow can form the main subject of a picture, but may seem a little flat on its own. Before taking this picture** *Timothy Beddow* **waited until he could include the figure of a passer-by. The final image is a clever contrast between the flatness of the shadow on the wall and the rounded form of the figure. The exposure was calculated in advance from a light reading taken in the lit area where the figure was expected to pass.**

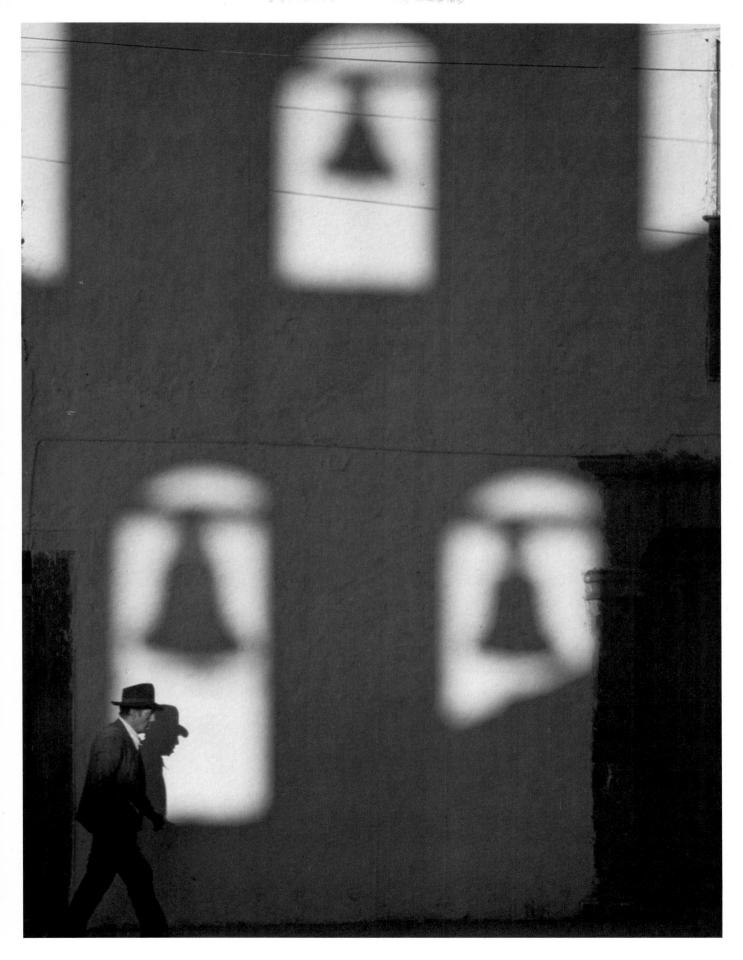

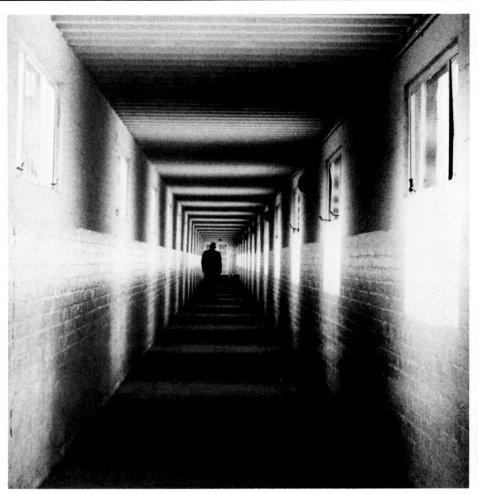

▲ The pattern of shadows from the tree overhead, superimposed on the shape of the door, has created a camouflage effect. With good, tight framing *Anne Conway* has isolated this one area to produce an almost abstract image.

► Passages and corridors often provide good opportunities to exploit unusual lighting effects. The strange shadows in this shot serve to strengthen the linear perspective and have added to the strong feeling of depth.

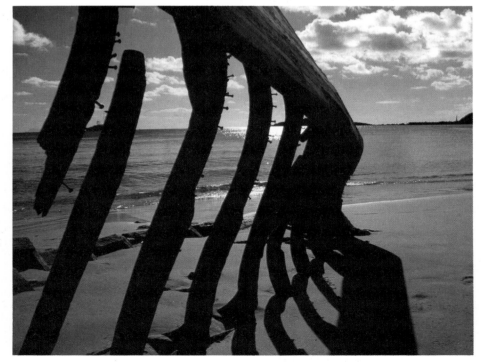

► Above: by slightly under-exposing the shadow of the girl in the deck-chair *Steve Herr* has suppressed the colour and detail in the bottom half of the picture. This provides the ideal neutral setting against which to contrast the richness of the colour in the highlight area above and also increases the impact of the shadow.

► Below: a similar technique has been used by *John Sims* for this fashion shot. By strengthening the shadow in the rest of the room, and so cutting out all distracting influences, attention is immediately focused on the one bright spot in the picture.

◄ A really black shadow thrown by a subject in silhouette can appear to attach itself to the object, so that together they form a new shape. By choosing a low viewpoint for this picture *William Cremin* has made the most of the drama in the shape formed by a skeleton of a boat and its shadow on a beach in the Caribbean.

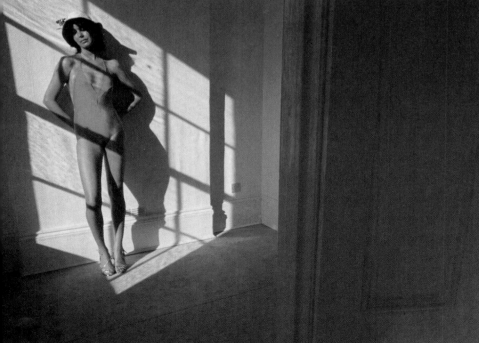

meter move the camera in close to the light and dark areas in turn before assessing the exposure for the effect you want.

As a general rule with colour transparency film, you should expose for the highlights. Over-exposed transparencies look 'ghostly' or washed out. This means, however, that the shadows may be strong and lacking in detail and must therefore be used as a definite design feature if they are to contribute to the main subject rather than detract from it. With black and white film, the greater brightness range allows you a little more control over shadows, but the same general rule applies. Before taking the picture you can get some idea of the final result by screwing up your eyes and squinting at the subject. This effectively stops down and 'under-exposes' your vision.

Using shadow

In their simplest form shadows can be used to give information in a picture—emphasizing the shape and form of a subject and indicating the time of day, the direction of the light and even the state of the weather. Used imaginatively they can also create a powerful image.

● Silhouetted shapes can add drama to a composition.

● Unwanted foreground or background detail can be played down by exaggerating the shadow area.

● An interesting shadow can actually form the main subject of your picture.

● A strong directional shadow can be used as an element of balance and also of perspective.

● The dappled shadow beneath a tree can give the subject an abstract effect.

● Shadow can provide a neutral setting to enhance the effect of bright colour or to separate areas of conflicting colour.

● Strong shadows can emphasize a shaft of light falling through a break in the clouds or between buildings in an urban landscape.

Look out for these opportunities and take advantage of them.

Usually the darker the shadow the more powerful the effect. But in colour photography a soft shadow very often brings out a range of subtle hues not found in brighter light. So, look for pale shadows as well as hard ones. The important thing is to be aware of shadow in the first place. Once you have noticed it the possibilities for its creative use in your pictures are practically endless.

Using light and shade

Whether photographing in black and white or in colour, there can be no doubt that the interaction of light and shade is one of the most important elements in a picture. It is fundamental to the visual representation of form, which is—99% of the time—what photography is all about.
Previous sections have discussed the effect of light in detail—this one looks at the complementary part of the story. That of shade and shadow.

Giving form

Photograph a subject with strong front lighting and it appears flat, because the only shadow is out of sight at the back. Move the lighting even slightly to one side and shadows appear on the subject itself and on other surfaces around it. The subject now assumes a sense of form and appears to be solid.
This is why a picture of a landscape taken at midday, when the shadows are shortest, is often less successful than the same view photographed in the early morning or late afternoon when the sun is lower in the sky and shadows are more prominent.
Sometimes you may want to create a flat, shadowless picture—for example, when the subject is full of complicated lines and patterns, or you need to record detail rather than shape or depth. However, if you want to express strong form the mixture of highlight and shadow is essential. This is especially important for showing the texture of your subject: conveying texture in a photograph depends almost entirely on the contrast between light and shadow.

▶ The midday sun is usually rather unflattering to outdoor scenes.
The almost total absence of shadow appears to flatten form in much the same way as strong front lighting in a studio. Here, however, *Alfred Gregory* has used the midday sun to advantage. The dark clouds of the approaching storm form a perfect backdrop for the bright, flat façades of the houses outlined in contrast against it.

▶ Below: the influence of shadow in a landscape becomes increasingly stronger as the sun sinks lower in the sky. A fairly ordinary scene at midday can be completely transformed by a pattern of shadows later in the evening. Here, *John Sims* has used the strong foreground shadows to offset the starkness of the silhouettes against the sky.

▲ Using strong front lighting *Chris Hill* has produced a flat, shadowless image of his subject. This places emphasis on colour and outline but gives little idea of form.

▲ The interaction of light and shade, caused by lighting to the side of the statue, gives the strong impression of form in this picture by *Dan Budnik*.

▼ The brightness of the day and the gentle activity at the ladies' bowls match are obviously the main features of this photograph by *Peter Beny,* and yet the role of the shaded area from the overhanging branches in the foreground is almost as important to the overall effect. Contrast with the shadow adds emphasis to the lightness of the rest of the composition.

▲ This photograph of peasants in Argentina was taken by *Alexander Low.* To communicate the bleakness of their existence he chose to picture them in the gloomy environment of shadow. This, together with the sombreness of their expressions, sets the mood of the picture. The highlights on the clothing and faces serve to accentuate, rather than relieve, the feeling of depression.

▶ An equal proportion of light and shade in a picture is likely to result in an uncertain mood. However, as this picture by *Anne Conway* shows, absence of mood can be an advantage for an abstract image.

Balance and mood

When composing a picture of a subject in contrasty lighting it is important to achieve a careful balance between the areas of light and shade. This will determine the final effect of the picture and has a great influence on mood.

Always remember that although bright light appears as white in a photograph and therefore immediately attracts attention, the blackness of shadow often records much 'heavier' than it appeared at the time and can be used as an important element in the design. This is especially true of really deep shadow which lacks all detail. Obviously, the darker the shadow the greater its influence will be.

Bearing these qualities in mind you can use them to offset each other. Take, for example, a crowded beach on a sunny day, or a busy market or city square. To capture the lively atmosphere of the scene the picture would have to be predominantly light and bright, yet the inclusion of a single area of strong shadow, probably to one side of the composition, would introduce a sober contrast and emphasize the vitality of the rest of the picture. Conversely, the sombreness of a shadowy interior can be exaggerated by the brightness of a shaft of light. In this way the interplay of light and shade becomes an important element in picture making.

With equal proportions of light and shade in a photograph the mood is likely to be uncertain, so keep the balance in favour of one or the other if you want to create atmosphere. Remember, too, that you can manipulate the density of shadow and the brightness of the light by your choice of exposure. This increases your control over the mood in your pictures.

Lighting for contrast

Contrast—or the relation of light and dark tones—is what gives the impression of form and distance in a photograph. It also helps in creating mood or atmosphere.

If the photographer can control it, an increase in contrast can add emphasis and impact to a picture. Equally, however, there are times when it is necessary to decrease contrast—for example, if you want to photograph a black cat against a white background. There are two main types of contrast. **Lighting contrast**—the difference between the brightness of the lit area and that of the shadow area—is influenced by the type of lighting, its distribution and its distance from the subject. To this is added **tonal contrast** —the tone of the elements in a picture

will also have an effect.

To see how contrast will appear on film, it helps to screw up your eyes tightly so that you can barely see the subject. Shadow detail disappears in much the same way as it does in a photograph, so you should be able to judge whether you need more contrast or whether you need to lighten the shadows to reduce contrast.

How light is distributed (where it falls or does not fall) has a great effect on the overall mood. For example, if light mainly falls on a small part of the subject—leaving the rest in shadow— the result is a dark, possibly dramatic, effect. If it covers the whole area then, not surprisingly, the picture will have a more relaxed feel.

The distribution of light can also be

used to separate the various elements and show their position, shape and size. If more, or less, light falls on the subject than on the background, the subject will be visually separated from the background and its shape and size will show up clearly.

Controlling indoor lighting

Creating contrast by limiting the distribution of indoor lighting is quite simple. One method is to move the lighting close up to the subject, so

▼ Lighting through a window isolates the figures from the background. The fall-off in light from the left is controlled by a reflector from the right. *Anthea Sieveking*

▲ Bright sunlight gives strong three-dimensional form and good contrast.
▼ An overcast sky produces a flat image but the good outline detail has the quality of a line drawing. *Suzanne Hill*

▲ These two photographs show how contrast can be heightened by bringing a light very close to the subject (right). The same

light was used for both— a diffused studio spot-light positioned as shown in the drawings. *Steve Bicknell*

▲ A snoot limits the lit area.

▼ A picture strong in lighting and subject contrast. Notice how the white garments stand out against their shadows. *Suzanne Hill*

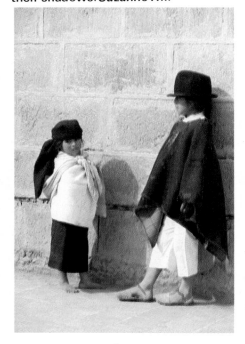

that the light falls primarily on the subject and not on the surroundings.

Not many photographers appreciate that the light can be brought right up to the very edge of the picture, so long as something is used to keep it from falling on the lens which would produce flare. (If you see the light source shining into the lens from the front, you can position a piece of cardboard, or similar object, between the light source and the lens to cut out the reflection. But do check that the cardboard does not appear in the picture.)

Close lighting causes diverging shadows and an extreme difference in brightness between one side of the picture and the other. As the brighter side is also the side where the highlights are, this gives extra intensity to the highlights. The resulting lighting is far more intense than the size of the source would have otherwise produced.

The background is dramatically darkened, too, as it is nearly always much further away from the light. So close-in lighting is a way of getting a very dramatic lighting combined with position, shape and texture, and a natural overall effect.

In a 'studio' situation, spotlights and floodlights with various shapes of reflector can be used to limit the distribution. A 'snoot' is useful for cutting down the light area too. This is a tube which is put over a light and limits its area to a small circle.

Natural light

Working in natural daylight, the problem is different: the photographer has less control. Often, the only way of stopping light flooding on to the background is to move the subject or wait for the light to change.

With a small source lighting, such as direct sunlight, there are plenty of shadow areas which can be used to create contrast—except perhaps in a flat, open area such as a beach with no nearby cliffs. In any case, small source lighting is usually easy to cut off. For instance a beach umbrella can be placed between the subject and the sunlight, or the subject itself can often be used to block off the light.

Varying the distribution with medium source lighting is not usually too difficult. For example, if you are working near a window, the subject is usually closer to it than the back-ground and so is more brightly lit.

Large source lighting casts hardly any shadow. It comes from almost every direction, and lights almost every part of the subject equally. Useful excep-tions are deep cave-like recesses such as doorways, or a path into a wood-land. If part of a subject is positioned against such areas of shade the subject will stand out clearly with its position, shape and size clearly defined.

This use of shaded areas, or cast shadows to make the main subject stand out well gives information about the subject, and helps to give a feeling

of quality to a picture. An impression of depth and richness is created, with a full range of tones.

Background

Although the tone of a background is not a factor of lighting, it can affect the choice of lighting. A light subject stands out well against a dark background and a dark subject stands out against a light background. It is only when the subject does not stand out that the photographer may look to lighting to make it do so.

Take, for example, a fair-haired child playing on a sandy beach; hair, skin and sand are all of a similar tone. To make the child stand out well from the background the photographer could either wait until the child moves to a part of the beach which has a nearby shadow, or find a way of casting a shadow over the child, such as with back lighting or a beach umbrella. But if a large, black dog should happen

to come and sit down behind the child the problem would be solved by the contrasting background.

The difference in background tone or its size need not be great. A slight movement of the camera to one side or the other can line up the subject against a small dark patch, so that it stands out clearly.

▶ Far right: tonal contrast is the result of carefully positioning the subject—a little to the right or left, he would not have stood out so clearly. *Richard Greenhill*

▶ The strong sunlight and light ground could have resulted in a very dull picture, but half-back lighting has at least put the girl's face in shadow.

▼ Here contrast is increased by placing the boy in shadow against a dark background. *S G Hill*

Controlling contrast

The previous section dealt with using lighting contrast effectively. But there are times when you want to reduce contrast—perhaps because it is unflattering to the subject, or because the film you are using cannot cope with the range of brightness in the scene.

If only one light source is used, and there are no reflecting surfaces to light the shadow area, the contrast will be very high. However, this is rare because usually there are surfaces nearby which lighten the shadows and reduce the contrast. If plenty of light is reaching the shadow area from other sources such as reflectors or other lamps, the shadow area may be almost as brightly lit as the lit area itself. The result—one with a good range of tones but no very black areas—will be a low contrast picture. Outdoors, lighting contrast often depends on the tone of the ground; for example, pale dust or sand, with their light, reflective surfaces, give lower contrast than grass or wet earth.

Contrast and light source

Is there any connection between lighting contrast and the size of the light source? This can cause confusion because a large light source is inevitably low contrast. In fact, large source lighting is often used to minimize a high contrast subject. Medium or small source light, on the other hand, can result in high or low contrast.

Does this confusion matter? It does if the photographer wants to be able to modify or control the lighting, because he needs to know which size of light source will give him the effect he wants. For example, small source light, with its small highlights, will tend to show up any sweat or oil on a portrait sitter's face. Reducing the lighting contrast by shining more small source lamps into the shadows will not help as each light will in turn create its own small highlights. But if you change to a larger light source, perhaps by bouncing the light off a white wall, the highlights spread out so that they are invisible.

Film and contrast

Lighting contrast is usually more pronounced to the camera than to the eye. Film cannot deal with more than a certain range of brightness, and this is another reason for knowing how to reduce excessive lighting contrast. There are three ways that this can be done, as shown in the series of photographs on the right. The photographer can put more light into the shadows, he

Lowering high contrast

Here is a typical example of a situation where the lighting contrast is too high. Two children are playing in a room which is lit by daylight coming through a large window from an overcast sky. Little light is reflected by the walls of the room compared with the main lighting. The face of the child with his back to the window is in shadow, while the other child faces the light. Any exposure setting will either

▲ Exposing for the lit area.
▼ Exposing for the shadow area.

under-expose one face (above) or over-expose the other (below).

What can be done? There are three basic alternatives.

● Lower the contrast by putting more light in the shadows (bottom right). A white or silver reflector, a white sheet or the matt side of silver-foil glued to cardboard, spread-out newspapers or a book could be used. Another way to

► **Both faces towards the light.**
▼ **A book used as a reflector.**

lower the contrast is to use fill-in flash.
● Change the composition so that the shadows do not matter (right). You could wait till the children are facing the light or you could move the camera position to be close to the window. The children would then be front lit and shadow areas so small as to be negligible. To get the exposure right, the camera could first be brought close in and the meter set from a lit area such as a child's face.
● Place all important parts of the subject in shadow and over-expose the lighter areas (see girl in hat overleaf). By moving round to shoot towards the light, the subject would be back-lit and the lit areas become negligible. The exposure should now be based on the shadow areas and a lens hood should be used to stop flare.

can move the subject to take better advantage of the available light or he can expose for the subject and accept the fact that he will have certain areas of over- or under-exposure.

Using the subject

The contrast of the lighting can be altered by using the reflection from objects within the picture area. Look for light-coloured areas of the subject which can be used as reflectors to throw light back into the shadows. For example, a hand or a book might be used to reflect light back on to a face. More locally, the colour of a subject also alters its response to lighting. For instance, contrast between highlight and lit area are greater for dark objects than for light-coloured ones. On the other hand, the contrast between the lit area and shadow area is greatest with light-coloured objects. For exam-

ple, a pale green apple might have a well-defined shadow and lit area, but a near-invisible highlight. A similar dark red one would have a well-defined highlight, while the lit area merges into the shadow.

Fill-in light

The problem with using a second light source to reduce contrast is that you may overwhelm, or at least threaten, the principal lighting. To prevent this, use a white reflector rather than a lamp of any sort, as the light it gives cannot be brighter than the principal light. Contrast-reducing, or fill-in, light should not normally be apparent to the viewer unless some special effect is required.

Direct flash is not usually suitable because it may be apparent if it is brighter or of a smaller source. It may also be noticeable if it is closer to the subject

or comes from an obviously different direction. So, ideally, fill-in light should not come from the opposite side. Although there is not always a choice, fill-in lighting should preferably be as frontal and as large-source as possible.

Look for natural reflectors

It's worth going out on a bright day and seeing just how many 'natural' reflectors you can find. Sand, light gravel, stone or concrete paths; a light-coloured awning, walls, the side of a car or a light-coloured boat; water; a towel; sheets on a washing line; a table cloth, a book or a newspaper—and, of course, light clothing.

But bear in mind that your subject will pick up the colour of the reflector. A green car may make your subject look unwell. It is usually possible to see where a natural reflector is throwing additional light on to the subject.

◄ A bird table acts as a reflector to light the lower half of the bird which would otherwise have been in shadow. It is the high contrast, with the subject well illuminated and the surroundings hidden in shadow, which shows up the small bird. Background details have been further suppressed by putting them out of focus. *John Walmsley*

◄ If the singer had only been lit by the strong overhead lighting most of her face would have been in shadow. But the book she is holding reflects light back into her face. This reflected light provides dramatic bottom lighting with its own set of highlights and helps separate the woman from the crowd. *Nick Hedges*

► By shading the girl's face from the harsh, overhead sun the main light source becomes the reflective areas all around her. This has changed a high contrast subject into one of low contrast. *Suzanne Hill*

◄ Contrast could have been too great here, but the photographer has skilfully positioned his subjects and himself so that the strong shadows and highlights add to the story of the picture. With the face in shadow it is, appropriately, the hands and the work of the sculptor which are given emphasis. By placing the sculptor's head in profile a strong silhouette is created against the light background. *Richard and Sally Greenhill*

Using more than one light

There are often times, especially when taking pictures indoors, when more than one light is needed to provide suitable lighting for a photograph. The number, direction and type of lights will depend on the subject itself and the impression that the photographer wishes to convey.

A person sitting at a table reading, for example, can be photographed in several ways—each of which presents a separate lighting problem. Lighting the whole scene is different from lighting just the person at the table, and photographing the hands holding the book requires a third approach. The overall effect must also be considered. Is the room to appear sunlit or is it after dark? Is the person young or old, male or female? Is it a serious or a light–hearted book, or are only the hands important? The atmosphere and sense of place and time for each shot will depend on the lighting.

Supplementing daylight

Suppose the room is to appear sunlit. The simplest way to light it would be to use daylight through the window, with reflectors to reduce the lighting contrast. To get some idea of how the film will record the lighting, squint at the subject through partially closed eyes before taking the picture.

If the day is overcast you may need to add some direct light through the window into the room to give the

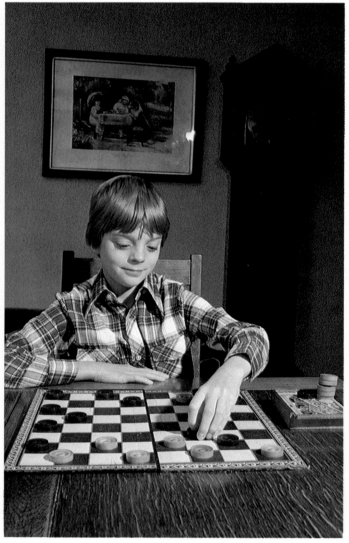

▲ One main light gives the subject form and modelling but also casts dense, hard shadows. With the exposure calculated for the lit areas of the face, the background is quite unnatural because of the narrow angle of the single light.

▲ A second light has been added, directed from the front to fill in some of the more dense areas of shadow. This second light is diffused by an umbrella so that it casts no secondary shadows. The effect is more natural but the background is still dark.

impression of sunshine. If the window frame is not to be included in the picture then you can decide where the 'window' light shall come from, irrespective of where the real window is. This flexibility is one great advantage of artificial light.

A window can be represented by a main, large source light 'shaped' by a large, flat sheet which casts shadows like a window frame. If you want to imitate pane-like shadows you can suspend a cardboard cut-out in front of the light. The heavy shadows thrown by the main light can be filled in by a reflector or by bouncing a second light off a wall or ceiling. This second light will look very unnatural if it has its own shadows, so it should be as large a source as possible.

Supplementing artificial light

If the room is to appear as if lit by domestic lighting, the approach will be very different. The main light will probably be placed high, where a ceiling light would be; it may be above or to the front of the person. A small source, perhaps a tungsten spotlight focused to give a broad beam, or a studio flash with an aluminium reflector, will throw shadows as if from a domestic ceiling light or standard lamp. Look at these shadows. How dominating are they, and do they seem to be in the right place? Move the key light

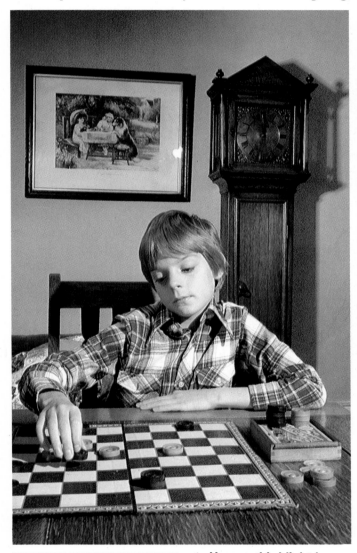

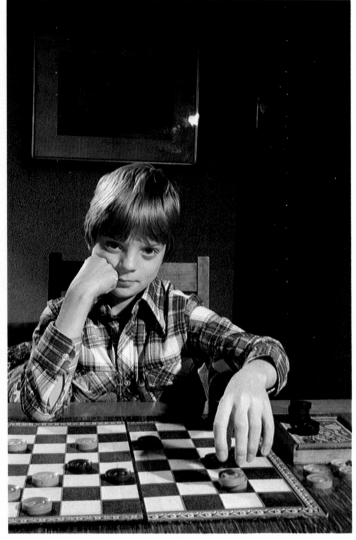

▲ Here, a third light has been directed at the background, balancing the room detail with the figure of the boy. Notice how a hard, unnatural shadow has been cast from the grandfather clock. To prevent this the third light should also have been diffused.

▲ Instead of lighting the background the third light has been raised and turned to light the hair and arms from the rear. This is a good way of separating a figure from a cluttered or unimportant background. A lens hood is essential to prevent flare.

about, and maybe adjust its intensity and shape until both shadows and highlights look correct.

Now bounce a second light off the ceiling or wall so that it illuminates the room around the table; try it with the key light turned off to see exactly where it falls. Move the second light around, if necessary modifying its fall with sheets of cardboard.

Turn both lights on together and it may become apparent that a third light, this time a spotlight with a snoot, is needed to light the hands. Perhaps this light will not be needed if the reader tilts the book to hide his hands while reflecting light from the pages or to his face.

Lighting is a process of planning aimed at making each light work to achieve a chosen end.

Lighting a face

If you are taking a portrait, you must again start with one key light. Its position—usually high and to the left, right or centre—is important. Place the light too low and the subject will look like Dracula; put it too far to one side and only one half of the face will be lit. as a general guide keep it above head height and at about 45°, pointing in the direction of the nose. Remember too that diffused light is kinder than that from a small source. Small source lighting tends to over–dramatize skin texture and show every pore and pim-

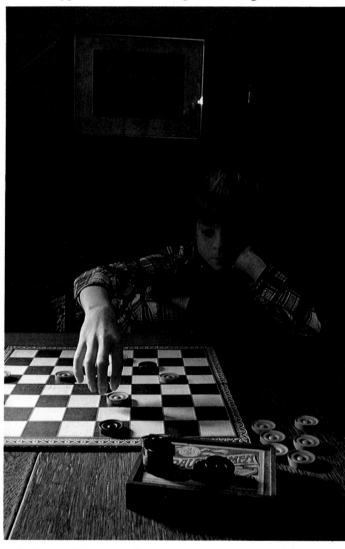

▲ To light the hands only the key light has been switched off and a snoot directed from behind the boy. Diffused light from the umbrella softens the hard lines of shadow. A longer exposure is needed to record some of the detail in the room.

▲ Don't overdo the amount of light—it can end up looking very artificial. Double side lighting like this was used in Hollywood in the 1930s for glamour shots, but is now a bit out–dated. Also, softer lighting tends to be more kind! *Michael Busselle*

ple. Diffused light should also illuminate the hands and if possible some of the background.

It may be enough to use just a reflector with the key light. If more fill–in is required, a light can be placed to shine from the camera, as near as possible along the lens axis. This will lessen the chance of getting double shadows and, if it is a fairly large source, it will light the table as well. Again, try each light one at a time, adjust them and then try both together.

Backlighting

A second or third light can be directed at the wall behind the subject. Alternatively, it can be positioned to shine into the hair from behind, so that the head shields the camera while each hair

appears to shine like a halo. Beware dry, fly–away hair: the specular highlights produced by this lighting can make individual strands look like string.

Suitable equipment

● Two lights should be sufficient equipment to start with. Choose large rather than small sources: it is easier to narrow a wide beam than the other way around.

● Snoots, barn doors, umbrellas and reflectors can be purchased, diffusing screens can be made and cardboard cut to maximize the lights' potential.

● If pictures are being shot in colour, be careful to use the right film. Tungsten and flash lights appear as different colours to different films;

▲ For this daylight effect *Michael Boys* used one hard light, above and to the right of the figure. Soft, fill-in light was produced by flash bounced from the ceiling. A Kodak 81EF filter warms up the cold light of the flash.

daylight film should be used with flash, tungsten film with photopearls. When using photofloods and tungsten film you need an 81A colour conversion filter. Never mix photofloods and photopearls.

● There are no fixed and fast rules about lighting. Everyone does it differently, but it always helps to look at good pictures and try to analyse how they were lit. Some of the advertisements in the glossier consumer magazines are good areas to research.

Mixing light sources: flash and daylight

Balancing flash with daylight, also known as synchro–sunlight, is used for three reasons: to reduce lighting contrast; to improve colour reproduction of shadows; or to create special effects. The technique consists of taking a daylight reading, setting it on the camera (at a shutter speed that synchronizes with the flash) and then positioning the flash gun.

It should be remembered that focal plane shutters (the kind found in most SLR cameras) will only synchronize with flash at fairly slow speeds. So, if you are using an SLR, choose a shutter speed of 1/60 or longer when mixing flash with daylight. Leaf shutters (used in most TLR and rangefinder cameras) will synchronize at any shutter speed. With either kind of shutter the flash exposure is controlled by varying the aperture or the distance of the flash unit from the subject.

Controlling lighting contrast

Often called fill–in flash, this technique is used to reduce the brightness range of a high contrast subject. An exposure difference beyond about two f stops between highlights and shadows is

◀ The inside of this hospital ward was very dark compared to the brightness of the daylight outside. To reduce the lighting contrast *Julian Calder* had to use three flash units on full power. Even so, with the exposure calculated for correct colour inside the room the outside detail in the top picture was burnt out. The only solution was to stop the lens down and slightly under–expose the interior (below). The colours inside remain acceptable while detail through the window is now seen quite clearly.

▼ Below left: Taken in available daylight only, when the light was poor. Below right: Combining flash with daylight to give more detail in both highlight and shadow areas. *Ron Boardman*

about the greatest range that most films can cope with. If the brightness range of your subject in daylight is greater than this then the detail and colour in either the highlight or the shadow areas will be lost. Filling in the shadows with a second light source reduces the contrast so that the film will record the same detail as seen by the eye.

You can use fill–in flash outdoors if the subject is not too large. For instance, you may want to take a picture of a person against a striking sunset. If you calculate the exposure in the normal way, to obtain good colour rendering of the sky, the figure will be under–exposed and appear in silhouette. An exposure calculated for detail in the figure will result in an over–exposed, washed–out sky. In these circumstances fill–in flash provides the ideal solution.

As already mentioned, with focal plane shutters it is the size of the aperture which governs the flash exposure and not the shutter speed. Therefore, by choosing an aperture which would

under–expose the photograph if you were using flash as the main light source you can fill in the heavy shadows yet maintain a natural lighting effect.

For example, if the recommended aperture for the camera to subject distance is f5·6, by changing the camera setting to 1/30 at f8 the sky will remain correctly exposed but the flash will not dominate the composition. This preserves the lighting balance.

▲ When using fill–in flash to control the lighting contrast it is important to preserve a natural lighting effect. For this picture *Julian Calder* stopped the lens down to f11 during an exposure of 1/15 second.

◄ Don't overdo the stopping down. Here a 1/4 second exposure at f22 was fine for the sky but too dark for the figure.

As a general guide, remember that the shutter speed must not exceed 1/60 for correct synchronization.

On a dull day, the flash can be used as the main light with the diffused sunlight as fill–in. Take a daylight reading and set the camera at one stop less (two stops for black and white). Because it is now the main light source the flash should be positioned to give a correct exposure at the set aperture. Hold the

flash gun on an extension lead well to one side and higher than the camera. In this position it will simulate light from the sun.

Indoors, the synchro–sunlight can be used to control the lighting contrast usually found by windows. The principle is the same—to record more detail in the shadow areas without using an exposure which will also burn out the highlights. Base the camera setting on the sunlight from the window and then divide the flash guide number by the aperture one greater than that set. This will give the flash to subject distance that will retain the lighting quality of the window light on slide film. Go two stops up for black and white.

Improving shadow colour

Daylight is not a constant colour. There are obvious changes at dawn and at sunset when the light becomes redder. During the day there are subtler changes. Blue is the dominant colour when the sun is hidden by clouds or when the subject is in shadow on a clear day. Smoke haze in or near towns turns the daylight reddish and open grass reflects a green cast.

The use of flash as main or fill–in light under such conditions will provide a light source of constant colour. It will also provide accurate reproduction of such critical colours as skin tones.

Flash can be used as a main light when the subject is completely in shadow. This might occur under a tree where the leaves make the light predominantly greenish, which makes skin tones look unhealthy.

Creating special effects

During the daytime subjects can be made to appear as if photographed at night by using flash as the main light. Set the camera so that it under–exposes the daylight by up to three stops with slide film or up to four stops with black and white negative material. Position the flash to correctly expose the subject at the aperture set on the camera. Exposing the film in this way will make

▲ A large subject outdoors is usually unsuitable for fill–in flash. Flash is not strong enough to cover any great expanse, and those areas which it does reach look unnatural in comparison to the rest of the scene. *David Morey*

◄ For this shot *Julian Calder* chose to allow the mellow influence of the tungsten bulbs to dominate the lighting. He used two flash heads, one bounced off the ceiling, one directed at the darker areas at the end of the room. To preserve the orange cast he fitted tungsten balanced acetate filters to the flash heads and waited until the late afternoon when the level of daylight had fallen.

► To fill in some of the shadows cast by the daylight from the window *Malkolm Warrington* needed to use flash. However, he did not want strong highlights to detract from the atmosphere of the picture. The final effect was achieved by bouncing a single flash off the high ceiling.

the areas not lit by flash appear dark. Only those parts which are flash–lit will be correctly exposed. The effect increases according to how much the daylight is under–exposed.

If tungsten film is used and a Kodak 85B colour conversion filter is fitted to the flash gun, two things will happen. Parts of the subject lit by the flash will appear with correct colour balance, but those areas lit by daylight will appear blue. By adjusting the exposure (before or after the flash is fired) the blueness of the daylight can be made to vary from a dark or dusk-like blue to a pale blue.

Synchro–sunlight can also be used to produce a double image of a moving subject. Take a picture of a running figure, say, at 1/60 using the technique. The slow shutter speed will yield a blurred image, superimposed on a sharp image recorded by the flash.

▼ By exposing for the flash–lit foreground, therefore under–exposing the daylight beyond, *Chris Alan Wilton* has made day seem like night. The effect is exaggerated by a graduated filter.

▲ This boy seems to be going backwards. The effect was created by using flash at the start of a 1/4 second exposure. The blurred image was then recorded by daylight. *Michael Busselle*

▶ *Julian Calder* took several shots of this eagle by using a very fast flash. Firing at 1/12,000 second, the flash was so fast that the bird did not see it and was not frightened away.

Mixing daylight and artificial light

In the last few sections we have only dealt with the use of light sources of matching colour temperature. This is likely to be of most use for studio work or when photographing outside in daylight. There will be times, however, especially when the daylight is fading or when working inside a building where the light sources are beyond your control, when you will encounter mixed lighting conditions: daylight mixed with tungsten light or daylight and fluorescent light. Each presents a different lighting problem.

Colour casts

Colour transparency film is balanced to give correct results in either daylight or artificial light. Consequently, when a picture is taken where both daylight and artificial light are present, one of them will produce a colour cast. If daylight film is used to photograph a subject lit by both tungsten and daylight the tungsten light will register an orange cast. If tungsten film is used the daylight areas will have a blue cast.

This effect can, however, be used to advantage. The warm glow of a table lamp in the background of a daylight indoor portrait, for example, can add a pleasing effect to a picture. Similarly, the blue cast of daylight at dusk when shooting a city lights scene can make the colours of window displays and signs look even more brilliant when the surrounding gloom is exaggerated by the use of tungsten film.

It is important to decide which part of the subject you want to record as a normal tone and to use the film which is balanced for the light which illuminates that area. It is usually preferable for the correct colour to occupy the greater proportion of the picture area and for the colour cast to provide an accent, rather than the other way round.

You will find at first that it is quite difficult to actually see the difference that a colour cast will make to your picture. For, although the alteration in colour is visible, our eyes tend to make an adjustment. When we read a book under tungsten light, for example, we

still see the pages as white, although they are in fact distinctly orangey, and daylight colour film will record them as being so. Experience is the best teacher in this instance and after taking a few pictures under mixed lighting conditions you will quickly learn to be able to anticipate the results.

Makes of film

The individual makes and types of colour film do not all produce the same results and the effect of a colour cast will depend to a great extent on which film you choose. Kodak Ektachrome 400 ASA, for example, is slightly more tolerant towards mixed lighting and the resulting colour casts are not as pronounced as they would be on, say, Ektachrome 64 ASA. Also, some people may find the cast produced by artificial light on daylight Kodachrome less pleasing than that produced on daylight Ektachrome.

It is very much a matter of personal taste—try several makes of film and see which you prefer.

Choice of exposure

Exposure is another factor which controls the effect of colour casts in mixed lighting. Take, as an example, a dusk shot which includes street lights in the picture area. If you expose for the darker areas the lights will be heavily over–exposed in relation to the rest of the scene, and the colour cast produced by shooting on daylight film will be largely 'burnt out' by this over–exposure. Similarly, a shot taken indoors by tungsten lighting and using tungsten film will show the light from a window as less blue if the exposure is calculated to bleach out the window area slightly.

Skin tones

Another thing to be wary of when incurring a colour cast in mixed lighting is the effect it will have on skin tones, particularly if these are a dominant part of the picture. In general an orange or yellowish cast on skin tones tends to be quite acceptable, sometimes even desirable, while a bluish cast can be

▲ **The choice of daylight film for this picture of Amsterdam enabled *Adam Woolfitt* to maintain the extraordinary magenta tint in the sky. Tungsten film would have rendered the lights more natural, but the resulting blue cast in the sky and over the water would have ruined the colours of the sunset.**

◀ **The highlights of tungsten light are almost as important in this picture as the boats at the pontoon. Again *Adam Woolfitt* used daylight film which has exaggerated the effect of the tungsten and so enlivened the whole of the picture.**

▶ **The mild blue sky of early evening has been intensified by the blue cast produced by tungsten film. The leaves lit by the street lamp, however, are the correct colour. The contrast in brightness between the tree and the sky is far more pronounced than it would have been had *Michael Busselle* used daylight film.**

Fluorescent and daylight

A further aspect of mixed lighting which needs special consideration is the presence of fluorescent or strip lighting. This may well appear to be of a similar colour quality to daylight but in practice this is far from so. Unlike tungsten light, which creates an attractive orange–yellow cast on daylight film, fluorescent lighting tends to record as an unexpected yellowish green, and unless you are aware of this effect you will receive an unpleasant surprise when seeing results shot with this light.

Correcting colour casts

Individual fluorescent tubes do vary, but the general trend is towards green on daylight film. It is possible to buy FL–D (fluorescent to day) correction filters but these are not usually strong enough. Filtration in the order of CC20–30 magenta is normally necessary, but of course this will have a very noticeable effect on the daylight or tungsten illuminated areas.

How, then, do you correct one colour cast without creating another? The only solution is to alter the colour quality of one or other of the light sources themselves.

In some cases filtering can be relatively simple. Shooting portraits indoors, for example, with a mixture of tungsten and daylight can be made colour correct by placing blue tinted acetates over the tungsten light sources, or by shooting on tungsten film and covering the window area with orange tinted acetates. These can be bought from professional cine stockists in a wide range of colours, including the standard daylight–tungsten conversion colours. It is also possible to buy aerosol spray cans of tinted transparent laquer.

However, this solution is not always practicable. For example, where very large areas of window are contributing

▲ The green cast typical of fluorescent lighting. Note, however, that the daylight at the window is the correct colour.

▼ A combination of CC25 magenta and CC10 yellow filters has corrected the green cast. The daylight is pink but acceptable.

▲ *Michael Busselle* used daylight Ektachrome 400 ASA film for this shot. It is fairly tolerant towards mixed light, whereas tungsten film would have produced blue skin tones.

to the lighting and the tungsten light sources are too numerous and inaccessible, as in the interior of a large building.

Under such conditions one must either accept the mixed colour or wait until dark and shoot only by the tungsten lighting. Alternatively, the problem can be solved by lighting the interior with flash, which is completely compatible with daylight. Use a long exposure and fire an electronic flash several times from different positions, each one illuminating a different part of the room. Used with care, the flash will generally overpower the effects of tungsten, or fluorescent, lighting.

◄ **A pronounced yellow cast can be acceptable, even desirable. Here** *John Sims* **used daylight film to exaggerate the effect of the artificial lighting.**

▼ **A fish eye lens has made a dramatic image from a simple subject, and again daylight film has increased the impact of the artificial light.** *John Sims*

Mixed lighting summary

Of all aspects of photography, lighting is possibly the most complicated. It affects almost all areas of composition, as well as the choice of exposure, lens and type of film. If the lighting is inappropriate for a particular situation you will almost certainly end up with an unsatisfactory picture; on the other hand, if the lighting suits the subject and mood you are trying to convey you are half way to a good photograph.

There are, of course, ways in which a photographer can control lighting. Judicious use of additional lighting—whether it be flash, tungsten or fluorescent—can improve, supplement or simulate available light and help to create a suitable atmosphere for the subject. Used badly, these additional light sources will destroy the original mood and create an unnatural picture. Earlier sections have dealt with the problems of mixing light sources like daylight and tungsten, or flash and daylight. What follows is a pictorial summary of the previous sections, designed as a guide to lighting effects on both daylight and artificial light film.

Breaking the rules

Like most rules, these guidelines are not to be regarded as inviolable laws. There may be occasions when it will be to your advantage to break them. For instance, you may *like* the effect of daylight recorded on tungsten film and consider that the predominantly blue cast suits your feelings towards the subject. In that case, by all means break the rules. Alternatively, when using flash, you may want your subject to stand out as though entirely separate from its background. It is then quite legitimate to ignore all the advice you have ever been given about achieving a balance between your subject and its surroundings.

The most important thing is to have a clear understanding of how different types of light will affect your film. Armed with this knowledge you should be able to pre-visualize any colour cast on the final image. Then, even if you don't have the right correction equipment, you will at least know when you can get a good picture and when you would be wasting your time.

TUNGSTEN–BALANCED FILM

◄ This is a typical example of mixed lighting conditions—an interior lit by both tungsten and daylight. Whatever film is used there will inevitably be a colour cast on the final image. *Angelo Hornak* filled in the shadow areas by placing a tungsten photographic lamp to the right of the camera. The left–hand side of the picture is more or less correct but the areas to the right are affected by the daylight and have a distinctly blue cast.

Below left: When using tungsten film for an interior shot it is best to wait until dark. There is then no daylight to affect the balance of the film. Again a tungsten photographic light was used to fill in the shadows.

▼ For this shot domestic bulbs were the only light source. The resulting image has an overall red cast. This is because tungsten film is balanced for photographic tungsten light and not for the much redder light of household bulbs.

DAYLIGHT FILM

▶ Daylight film is the obvious choice when the subject is lit by daylight only. However, as this picture shows, daylight is rarely sufficient to light the whole of an interior and in spite of a 6 second exposure the shadows are still too dark.

▼ The lighting for this shot was a mixture of daylight and two flash heads to fill in the areas of shadow. The flashes were fired four times, the camera lens being covered during recycling. The effect is very natural and shadow detail is good. However, as the combined effect of the flashes cannot be seen until the film is processed, this technique is largely a matter of guesswork.

DAYLIGHT FILM
◄ To eliminate the element of guesswork when using fill–in lighting a constant light source must be used. The effect can then be seen before the picture is taken. Here, *Angelo Hornak* used a tungsten lamp. The shadows are filled in but the film has recorded the tungsten–lit areas with a strong orange cast—a typical problem with mixed light sources.

▼ The ideal solution to mixed lighting conditions when the light sources are within your control is to change the colour temperature of one of the sources. Here *Angelo Hornak* used tungsten fill–in. To balance the light he placed a blue filter over the tungsten lamp.

Night photography

Taking your camera out at night can be more exciting and challenging than photographing by daylight, even—perhaps especially—when you leave your flash gun at home. The night photographer uses the lights that man and nature have devised to illuminate the darkness, which are more diverse and colourful than daylight. And photography thrives on variety.

During the day our eyes see clearly and we expect the camera to reproduce what we see. At night most people's eyes not only see a bare minimum, but often see it in less brilliant colour, less detail and with less clarity. The camera, however, can see colours which we cannot see at night, and look into dark shadows which our eyes cannot penetrate. One bright light in the darkness can prevent the human eye from adjusting to darker areas. The camera has no such limitations, and this is the beauty of night pictures.

Light sources

With a minimum exposure, the camera will only reproduce light sources: street lights, for example, car headlights (still or moving), lighted windows, signs, the moon and stars, reflections on water and so on. Fires, fireworks, TV screens and decorative illuminations are also all light sources. These subjects give us pictures of the colour, shape and movement of the lights themselves rather than any scenes they illuminate. Light sources can be photographed with fairly short exposures and there is often a choice between freezing moving lights or letting them make streaks of light on the film, as happens with moving car tail-lights.

The human eye does not normally see just the light sources: as well as all the neon signs at Piccadilly Circus or Times Square, we expect also to see detail of the buildings and streets. You can set your camera's highly selective exposure to leave out all this.

Lighted subjects

When photographing lighted subjects at night, minimal changes in exposure have more effect than on light sources. With more exposure, detail in the darkest areas becomes visible, while often the detail in lighter areas remains good as well. Moonlit scenes often look as bright as day, with blue skies, good colours, shadows with soft edges, and full detail—though the object with such pictures is usually not to simulate daylight but to go halfway to producing a night effect with good detail.

▲ Backlighting makes the most of this fountain by day, but its own lights give a far better effect by night. Note how long night exposure turns drops of water into a stream. *Dan Budnik*

▼ With a hand-held meter, *Robert Glover* had already worked out an exposure for a candlelit face (1/30 at f2 on 200 ASA film) so that for this shot he was free to watch for the right moment.

Light and subject

For some pictures you will want to show both the light source and the subject which it illuminates. The closer your subject is to the light, the better the result. Normally you will have to accept that the light will be slightly too bright while the subject is rather too dark, but an exception is where you use a reflective surface—a window or a wet street—to reflect the light source. A face has a slightly shiny surface and reflects better if you photograph it with the light behind it and slightly to one side—even including the light in your picture—than with the light coming over your shoulder. Instead of a dim, full-face portrait you will have a brighter, rim-lit profile, leaving the rest of the face in semi-silhouette.

Exposures

Exposures for night photography vary considerably, and the exposure you choose will depend on the scene and the effect you want. This makes it difficult to give precise guidelines for exposures though you may find the table of rough exposures overleaf useful as an initial guide. The table takes account of one complicating factor, known as reciprocity law failure.

▶ On 50 ASA daylight film, this shot was exposed for 30 secs at f22. Longer would have shown more detail on the tower but may have spoiled the balance, making the whirling lights too bright.

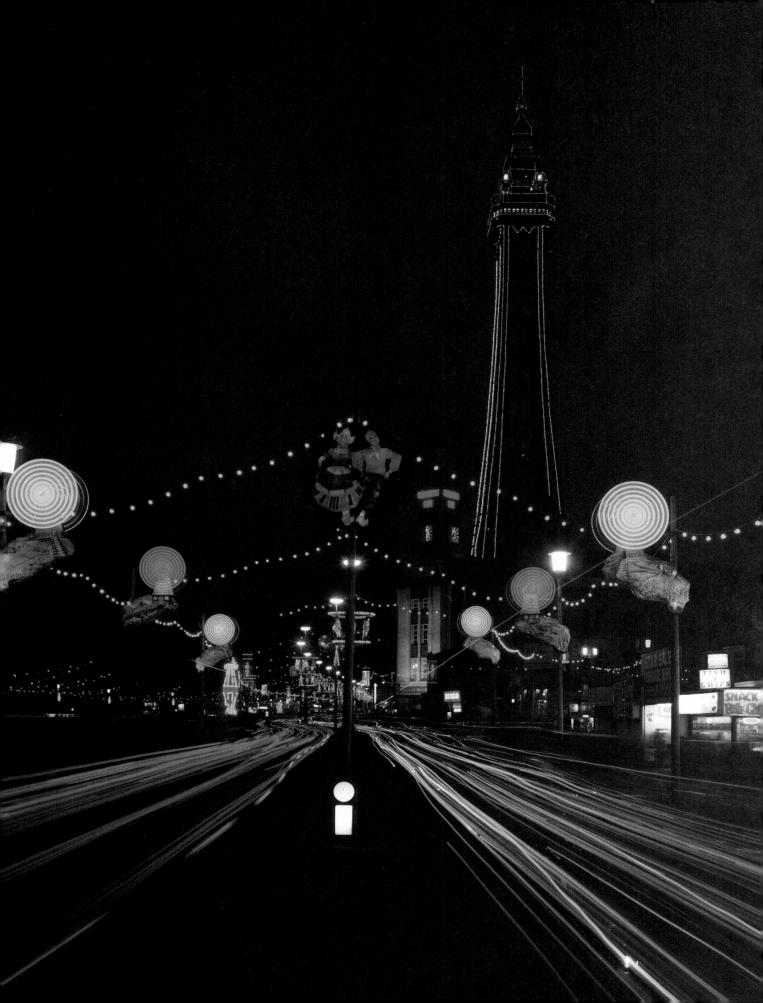

Reciprocity law failure refers to the fact that, with very long exposures, halving the aperture no longer has the same effect on exposure as doubling the shutter opening time. For exposures faster than 1/10, there is no problem. For exposures between 1/10 and 1 second, you should allow half a stop extra, and for exposures between 1 and 100 seconds allow between one and two stops extra. Always bracket exposures to be certain, preferably by altering the aperture setting rather than the shutter speed.

To complicate matters further, if you are working with slide films the density contrast and colour will change with different exposures. Trial and error is your best guide: take readings from different parts of the picture, allow extra time, make plenty of different exposures and keep notes on each one so that you can learn by experience.

With slide film, to get black shadows you must expose for the highlights: with negative film—colour or black and white—you need make fewer exposures because you can vary the effect by printing darker or lighter later on. Expose to give detail everywhere and then print to make the shadow black or detailed as you wish.

Meters

Most modern hand-held meters are of the CdS or silicon type and can get a reading in a lit night scene, but few TTL meters will. Even with the better TTL meters—Canon EF or Olympus OM-2—you should ideally use a hand-held meter as well. A few good hand-held meters will actually give a reading in moonlight.

As a general rule, if you want to record clear detail, measure the brightest part of the scene and allow three f stops more exposure, or eight times the shutter opening time, This method is equally effective with a hand-held meter or with a TTL meter used close up to the subject. TTL meters which take an average reading or are weighted towards the centre of the frame—but not spot meters—are also accurate for working out the exposure for neon signs and other light sources: move close enough for the sign to occupy one-third to half the picture and use the resulting setting from wherever you shoot the picture. Even with the best possible exposures, you should expect colour to change slightly, but your results will generally be creatively acceptable. Our own eyes do not see colours correctly at night.

Subject	Type of lighting	Effect	Settings (400 ASA film)
Street scene	strong city centre lighting, sodium or mercury vapour	dark	1/125 f4
		bright	1/60 f2·8
	small town, modest lighting	dark	1/60 f2·8
		bright	1/30 f2·8
Shop window	small store	normal	1/30 f2·8
	spotlit items	normal	1/60 f4
	very bright	normal	1/125 f4
Street lights Christmas lights	mixed	lights only	1/125 f8
		lights only	1/125 f5·6
		street as well	1/60 f4
Bonfire	wood	just fire	1/125 f4
		fire and faces of onlookers	1/60 f2·8
Fireworks	mixed	light source	1/60 f4
	sparklers	to illuminate face of holder	1/30 f2·8 45cm away
Car lights (rear)		light source	1/30 f2
		streaks	10 secs f8 50 mph
Neon signs		light source	1/60 f4
Floodlit buildings	various	normal	1/30 f2·8
Moonlit landscape	full moon	normal	20 mins f5·6
	half moon	normal	2 hrs f5·6
	full moon	moonlight	4 mins f5·6
	half moon	moonlight	20 mins f5·6
The Moon	clear night	detail surface	1 sec. f4 200mm lens

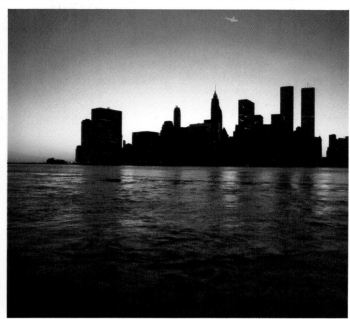

These photographs of the Lower Manhattan skyline were taken over half an hour in rapidly falling dusk light. *Clive Sawyer* kept an aperture of f4 for all of them, adjusting only his shutter speed to deal with the changing lighting conditions.

The first shot (above) was exposed at 1/30, too fast to show anything but a dim silhouette with barely any artificial lights visible. The second (above right) was taken at 1/8, long enough for the lighted windows to begin to show, and incidentally boosting the lingering sky light. The third shot (right) was exposed for the city lights and their bright reflections in the water: in this case the shutter was left open for 5 seconds.

◄ A powerful light source will require only a short exposure. Using a 200mm Nikkor lens to isolate this Tokyo shop sign, *Alfred Gregory* set an exposure of 1/60 at f4 with type B (tungsten balanced) 200 ASA Ektachrome. The slight flare across the picture is caused by reflections from glass in front of the sign.

Film

You will get the greatest latitude for night photography by using a fast film, preferably 400 ASA film of any type. Fast film tends to be rather grainy, but it is better to get results with grain than no results at all. If you need still shorter exposures, all types of 400 ASA film can in fact be pushed to higher speeds: 800 ASA or 1600 ASA and in rare cases to 3200 ASA. With black and white film you can do this yourself by increasing the development times. Note: all exposures on the same film will be affected. With colour film, the enthusiastic experimenter can sometimes get good results from push processing, but processing laboratories offer special services which may be more reliable, though they cost two or three times the normal processing cost. Of course if you are using a tripod and can accept a blurred subject, you can use a slower film. For most night photography the make and type of film is not important. With colour slides, however, you may prefer to avoid the warm, rather orange tones that daylight film gives with floodlit shots, shop windows and other artificial lighting. To compensate for this use a blue (D to A) filter and give an extra stop on exposure, or load your camera with a tungsten balanced film—Agfachrome 50L, for example, or Ektachrome 160 Tungsten.

Equipment

A tripod is almost essential when photographing at night: choose one that is easy to set up with gloves on (some are very awkward indeed).
Avoid small locking screws or adjustments. Never fix your camera to the tripod in the dark: fix it first in your car or indoors to avoid the risk of failing to thread it correctly without realizing it.
Keep your camera in your car or under your coat as much as possible. If it gets too cold the shutter may become sluggish, and very cold weather can make the film brittle. Avoid loading film in the dark, or changing lenses (unless they are of a good bayonet type, with

locating warts). Never take your camera indoors from cold conditions with the lens removed: contrary to popular opinion, cameras do not mist up out-of-doors, but when they re-enter a warm, moist atmosphere. If misting does occur, leave any filter in place and never remove the lens or try to clean the mirror. Misting does no harm if allowed to evaporate normally. There are some useful aids to night photography: though only available light photography is discussed here, you may find a flash gun with illuminating dials useful for emergency viewing. A small torch is valuable, and so is the illuminating dial of an LCD watch: you can also buy inexpensive ballpoint

▲ *Eric Hayman* arrived at the exposure for this shot by taking a TTL meter-reading from the sky and then under-exposing it by 1½ stops to get the motorway in silhouette. With 64 ASA film this gave him 1 sec at f11.

◀ For a correct balance between the artificial light sources and the vestige of sky light, *Dan Budnik* had to bracket exposures—particularly as he was using Kodachrome which allows no leeway for adjustment in processing.

▶ *Robert Estall* took this shot of Piccadilly Circus on a 17mm lens open at f8 for 10 secs. This was long enough for a car to complete a right turn leaving a trail of yellow flashes.

▼ Mixed artificial lights can give un-predictable results: here *Laurie Lewis* used tungsten balanced film which has a bluish bias but copes well with lights ranging from floodlights to lasers.

pens which incorporate a torch for writing at night.

Few other accessories are needed. A watch—preferably with a second hand—is more important than any photographic extras. Some cameras have shutters with speeds up to 30 seconds, but most only go up to 1 second, and you will often need far longer exposures. One rather useful idea for night photography is the focusing light—a small torch fixed to your camera, aimed at the centre of the viewfinder's picture so that you can use the focusing screen at night. Another useful new idea is the auto-focus camera: some will not work at night, but others, particularly those with a light beam, can cope with darkness. The subject must be fairly central.

Glossary

Words in *italics* appear as separate entries.

A

Aperture The circular opening within a camera lens system that controls the brightness of the image striking the film. Most apertures are variable—the size of the film opening being indicated by the f number.

Artificial light This term usually refers to light that has specifically been set-up by the photographer. This commonly consists of floodlights, photographic lamps, or flash lights (electronic or bulb).

ASA American Standards Association. The sensitivity (speed with which it reacts to light) of a film can be measured by the ASA standard or by other standards systems, such as DIN. The ASA film speed scale is arithmetical—a film of 200 ASA is twice as fast as a 100 ASA film and half the speed of a 400 ASA film. See also *ISO*.

Available light A general term describing the existing light on the subject. It normally refers to levels of low illumination—for example, at night or indoors. These conditions usually require fast films, lenses of large aperture—for example, f2—and relatively long exposure times.

B

Back light A light directed on to the subject from behind so the subject is between the back light and the camera. This gives a silhouetted subject with a tracing of light around the outer edge of the subject, and is sometimes referred to as rim lighting.

Barn doors A flap-like attachment which fits around the rim of a light. They are adjusted like car visors, and can be used to control light falling on the subject or to prevent light shining directly into the camera lens.

Between-the-lens shutter A shutter located between the lens elements and normally next to the aperture blades. Found on most non-reflex 35mm cameras.

Bounce light Light (electronic flash or tungsten) that is bounced off a reflecting surface. It gives softer (more diffuse) illumination than a direct light and produces a more even lighting of the subject. There is a loss of light power because of absorption at the reflecting surface and the increased light-to-subject distance. It is best to use white surfaces since these absorb only a small amount of light and do not impart any colour to the illumination.

Bracketing To make a series of different exposures so that one correct exposure results. This technique is useful for non-average subjects (snowscapes, sunsets, very light or very dark toned objects) and where film latitude is small (colour slides). The photographer first exposes the film using the most likely camera setting found with a light meter or by guessing. He then uses different camera settings to give more and then less exposure than the nominally correct setting. An example of a bracketing series might be 1/60th sec f8, 1/60th sec f5·6, 1/60th sec f11, *or* 1/60th sec f8, 1/30th sec f8, 1/125th sec f8.

Brightness range The brightness difference between the darkest and the lightest parts of a scene (or image). This range depends on the reflectance of the various objects in the scene and on the nature of the illumination. On a sunny day with few clouds this range may exceed 1:100, but the same scene on a dull day may have a brightness range of less than 1:20. With careful exposure and development, both these conditions can be accommodated by the film. See also *Lighting ratios*.

C

Cadmim sulphide cell (CdS) A type of cell used in some hand-held light meters and some built-in camera meters. The resistance of the cell to a constant electrical voltage (supplied by a battery) changes as the light falling on the cell varies. The resulting current is either used to move a pointer on a scale or employed directly to alter the camera's shutter speed or aperture. CdS cells are more sensitive than selenium cells and are ideal when photographing in dim lighting conditions.

CdS see *Cadmium Sulphide cell*.

Colour temperature Different white light sources emit a different mixture of colours. Often, the colour quality of a light source is measured in terms of colour temperature. Sources rich in red light have a low colour temperature—for example, photofloods at 3400 (Kelvin)—and sources rich in blue light have a high colour temperature—for example, daylight at 5500K. Colour films have to be balanced to match the light source in use, and films are made to suit tungsten lamps (3200K) and daylight (5500K).

Contrast The variation of image tones from the shadows of the scene, through its mid-tones, to the highlights. Contrast depends on the type of subject, scene brightness range, film, development and printing.

Conversion filter Any filter which converts one standard light source to another standard light source. For example, a Wratten 85B filter converts daylight to photoflood type illumination. This filter, when placed in front of the camera lens, enables a camera loaded with tungsten colour film to give correct colour photographs in daylight. To compensate for the light absorbed by the filter, it is necessary to give extra exposure. This is determined by the filter factor.

D

Daylight colour film A colour film which is designed to be used in daylight without or with electronic flash or blue flash-bulbs. This film type can also be used in tungsten or fluorescent lighting if a suitable filter is put in front of the lens or light source. See also *Tungsten film* and *Colour temperature*.

Depth of field The distance between the nearest and furthest points of the subject which are acceptably sharp. Depth of field can be increased by using small apertures (large f numbers), and/or short focal-length lenses and/or by taking the photograph from further away. Use of large apertures (small f numbers), long focal-length lenses, and near subjects reduces depth of field.

Diffused image An image which has indistinct edges and appears 'soft'. Overall- or partially-diffused images can be produced in the camera by using special lenses and filters, or by shooting through various 'filmy' substances such as vaseline, sellotape, and fine stockings. Images may also be diffused during enlarging by placing a diffusing device between the enlarging lens and the paper.

Diffuse light source Any light source which produces indistinct and relatively light shadows with a soft outlilne. The larger and more even the light source is, the more diffuse will be the resulting illumination. Any light source bounced into a large reflecting surface (for example, a white umbrella, white card, or large dish reflector) will produce diffuse illumination.

DIN Deutsche Industrie Normen. A film speed system used by Germany and some other European countries. An increase/decrease of 3 DIN units indicates a doubling/halving of film speed, that is a film of 21 DIN (100 ASA) is half the speed of a 24 DIN (200 ASA) film, and double the speed of an 18 DIN (50 ASA) film. See also *ISO*.

E

Electronic flash A unit which produces a very bright flash of light which lasts only for a short time (usually between 1/500-1/40000 second). This electronic flash is caused by a high voltage discharge between two electrodes enclosed in a glass cylindrical bulb containing an inert gas such as argon or krypton. An electronic flash tube will last for many thousands of flashes and can be charged from the mains and/or batteries of various sizes.

Exposure meter An instrument which measures the intensity of light falling on (incident reading) or reflected by (reflected reading) the subject. Exposure meters can be separate or built into a camera; the latter type usually gives a readout in the viewfinder and may also automatically adjust the camera settings to give correct exposure.

F

Fast films Films that are very sensitive to light and require only a small exposure. They are ideal for photography in dimly lit places, or where fast shutter speeds (for example, 1/500) and/or small apertures (for example, f16) are desired. These fast films (400 ASA or more) are more grainy than slower films.

Fill light Any light which adds to the main (key) illumination without altering the overall character of the lighting. Usually fill lights are positioned near the camera, thereby avoiding extra shadows, and are used to increase detail in the shadows. They are ideal for back-lit portraits, studio work, and where lighting is very contrasty (such as bright cloudless days).

Filter Any material which, when placed in front of a light source or lens, absorbs some of the light coming through it. Filters are usually made of glass, plastic, or gelatin-coated plastic and in photography are mainly used to modify the light reaching the film, or in colour printing to change the colour of the light reaching the paper.

Fisheye lens A lens that has an angle of view greater than 100° and produces distorted images—lines at the edges curve inwards. Fisheye lenses have an enormous depth of field and they do not need to be focused.

Flare A term used to describe stray light that is not from the subject and which reaches the film. Flare has the overall effect of lowering image contrast and is most noticeable in the subject shadow areas. It is eliminated or reduced by using coated lenses (most modern lenses are multi-coated), lens hoods and by preventing lights from shining directly into the lens.

Flash See *Electronic flash*, and items listed below.

Flashbulb A glass bulb filled with a flammable material (such as magnesium or zirconium) and oxygen, which when ignited burns with an intense flash of light. Flashbulbs are usually triggered by a small electrical current and are synchronized to be near their peak output when the shutter is open. Flashbulbs have been largely superseded by electronic flash.

Flashcube An arrangement of four flashbulbs that are positioned on four sides of a cube—the cube being automatically rotated to the next bulb after one is fired. The bulbs are fired either by a small electrical current or by a simple percussion mechanism (Magicube).

Flat image An image of low contrast, which may occur because of under-exposure, under development, flare, or very diffuse (soft) lighting.

Floodlight A tungsten light (usually 250 or 500 watts) which is within a relatively large dish reflector.

Focal length The distance between the optical centre of the lens (not necessarily within the lens itself) and the film when the lens is focused on infinity. Focal length is related to the angle of view of the lens—wide-angle lenses have short focal lengths (for example 28mm) and narrow-angle lenses have long focal lengths (for example, 200mm).

Focal plane The plane behind the lens that produces the sharpest possible image from the lens—any plane nearer or farther from the lens produces a less sharp image. For acceptable results the film must be held in the focal plane.

Focal plane shutter A shutter that is positioned just in front of the film (focal plane). The exposure results from a slit travelling at constant speed across the film—the actual shutter speed depending on the width of the slit. As a focal plane shutter is built into the camera body, it is not necessary for lenses to incorporate shutters. See also *Shutter*.

Fogging The act, usually accidental, of all or some parts of the photographic material being developed as a result of something other than exposure to the image. Fogging can be caused by light leaks, chemical contaminants, radiation, static discharges, and mechanical stress.

G

Grain The random pattern within the photographic emulsion that is made up of the final (processed) metallic silver image. The grain pattern depends on the film emulsion, plus the type and degree of development.

Graininess The subjective measurement of the grain pattern. For instance, fast films when greatly enlarged produce images that are very grainy, and slow films give relatively 'grainless' images.

H

Highlights Those parts of the subject or photograph that are just darker than pure white eg. lights shining off reflecting surfaces (sun on water, light shining through or on leaves). The first parts of a scene or photograph to catch the eye of the viewer are likely to be the highlights—it is therefore important that they are accurately exposed and composed.

I

Incident light The light that falls on the subject rather than that which is reflected from it. Light meter readings that measure incident light (incident readings) are not influenced by the subject and are preferred when photographing non-average subjects, such as objects against black or white backgrounds.

ISO International Standards Organization. The ISO number indicates the film speed and aims to replace the dual ASA and DIN systems. For example, a film rating of ASA 100, 21 DIN becomes ISO 100/21°.

K

Kelvin A temperature scale which is used to indicate the colour of a light source. Reddish sources, such as domestic light bulbs, have a low colour temperature (about 3200K); and bluish sources (eg daylight at 5500K) have higher colour temperature values. The Kelvin scale equals Celsius temperature plus 273, thus 100 degrees C equals 373K.

Key light The main light source in a lighting set-up which is usually supplemented by other less powerful lights and possibly reflectors. The key light sets the overall character of the lighting.

L

Leaf shutter A type of lens shutter which is usually built into a lens and operates by several metal blades opening outwards to reveal the diaphragm aperture and then closing when the exposure time is completed. Leaf shutters have the advantage of being able to synchronize with flash at any speed but only have a top speed of 1/500 second.

Lens hood (shade) A conical piece of metal, plastic or rubber which is clamped or screwed on to the front of a lens. Its purpose is to prevent bright light sources, such as the sun, which are outside the lens field of view from striking the lens directly and degrading the image by reducing contrast (flare).

Light The part of the electromagnetic spectrum to which human eyes are sensitive.

Lighting ratios This refers to the comparative intensities of the main (key) light source and the fill-in light(s). For example, a studio portrait may be lit by a main light that is four times the intensity of a fill-in light (which lightens the shadows); this represents a lighting ratio of 4:1. For outdoor photography the lighting ratio depends on the weather conditions—a cloudless day representing a high ratio, and an overcast day (where the clouds act as reflectors) a low lighting ratio.

Light meter See *Exposure meter.*

Low key This describes any image which consists mainly of dark tones with occasional mid and light tones. Low key photographs are used to indicate seriousness, dignity, strength, sadness and mystery.

M

Memory lock A device on a camera that holds or 'locks' the shutter speed/aperture combination already determined by the internal light meter.

Modelling light The tungsten lamp situated within a studio electronic flash unit, which shows fairly accurately how the lighting will appear in the final photograph.

O

Open up A slang term which means to use a larger aperture (for example, from f8 to f5·6). The opposite terms is 'close down', that is reduce the aperture.

Overdevelopment Development which is longer than the recommended time. Overdevelopment causes increase in contrast, graininess and fog level, and a loss in sharpness. Occasionally overdevelopment can be used to good advantage when lighting is dim.

Over-exposure Exposure which is much more than the 'normal' or 'correct' exposure for the film or paper being used. Over-exposure can cause loss of highlight detail and reduction of image quality.

P

Pentaprism An optical device, used on most 35mm SLR cameras, to present the focusing screen image right way round and upright.

Photoflood An over-run (subjected to a higher voltage than the bulb is designed for) which gives a bright light having a colour temperature of 3400K.

R

Rangefinder A device incorporated into some cameras which helps focus the camera lens. Correct focus is achieved by turning the lens focusing ring until the double or split image produced by the rangefinder is aligned in the viewfinder.

Reciprocity law failure Failure of the reciprocity law (which states: exposure = image brightness at the focal plane x shutter speed) manifests itself in loss of sensitivity of the film emulsion and occurs when exposure times are either long or very short. The point of departure from the law depends on the particular film, but for most camera films it occurs outside the range 1/2-1/1000 second, when extra

exposure is needed to avoid under-exposure.

Red eye The phenomenon of red eyes can occur when taking colour portraits by flashlight. It is avoided by moving the flashgun further away from the camera.

Reflector Any surface which is used to reflect light towards the subject, and especially into the shadow areas. They may be curved metal bowls surrounding the light source or simply a matt white board.

Rim light Light placed behind the subject to give a pencil of light around the subject's outline. Rim lighting is often used to highlight hair.

S

Saturation The purity of a colour. The purest colours are spectrum colours (100% saturation) and the least pure are greys (0% saturation).

Scattering of light The bending of light caused by interaction of light waves with small particles of matter. Scattering occurs in the atmosphere and within photographic emulsion.

Shutter The device which controls the duration of exposure. See *Focal plane shutter* and *Leaf shutter.*

Single lens reflex (SLR) A camera which views the subject through the taking lens via a mirror. Many SLRs also incorporate a *pentaprism.*

Skylight filter A filter which absorbs UV light, reducing excessive blueness in colour films and removing more distant haze. Use of the filter does not alter camera settings that is, filter factor x1.

Snoot Cone-shaped lamp attachment which concentrates the light into a small circular area.

Soft-focus lens A lens designed to give slightly unsharp images. This type of lens was used primarily for portraiture. Its results are unique and are not the same as a conventional lens defocused or fitted with a diffusion attachment.

Spotlight A light source which produces a concentrated beam of light. Spotlights give hard-edged shadows and are used as a main light or to accentuate a particular subject feature.

Spot meter An exposure meter which reads off a very small area of the subject. Spot meters have an acceptance angle of only one or two degrees. Their usefulness depends on careful interpretation by the photographer.

Star filter When placed in front of the camera lens, a star filter gives a star-like appearance to strong highlights. They are usually available to produce 2, 4, 6 or 8 points to the star.

Stop Another term for aperture or exposure control. For example, to reduce exposure by two stops means to either reduce the aperture (for example f8 to f16) or increase the shutter speed (1/60 sec to 1/250 sec) by two settings. To 'stop down' a lens is to reduce the aperture, that is, increase the f-number.

Strobe light American slang for 'electronic flash'. More precisely, a strobe light is a pulsating electronic flash unit which repeats its flash at regular intervals. The rate of flashing can often be varied. They are used for cine work, multiple exposures, and in discotheques.

Synchronization The precise timing of flash light with the camera shutter. When using electronic flash the camera should be set on X sync and a shutter speed of 1/125 sec or longer (see camera instructions) for focal plane shutters and any speed with leaf shutters. With flashbulbs use M sync and 1/60 sec or longer (see camera instructions). If only X sync is available, then use flashbulbs at 1/8 sec or longer.

Synchro-sunlight The combining of daylight and flash light. This technique is often used to fill-in harsh shadows on bright sunlit days. For colour work do not use clear flashbulbs.

T

Telephoto lens A long focal-length lens of special design to minimize its physical length.

Through-the-lens (TTL) metering Any exposure metering system built into a camera which reads the light after it has passed through the lens. TTL metering takes into account filters, extension tubes and any other lens attachments. These meters give only reflected light readings. See also *CdS cell.*

TLR See *Twin lens reflex.*

Tonal range The comparison between intermediate tones of a print or scene and the difference between the whitest and blackest extremes.

Tripod A three-legged camera support. Various tripod heads are available offering a variety of adjustments, and some tripods also have a centre column for easy height control.

TTL metering See *Through-the-lens metering.*

Tungsten film Any film balanced for 3200K lighting. Most professional studio tungsten lighting is of 3200K colour quality.

Tungsten light A light source which produces light by passing electricity through a tungsten wire. Most domestic and much studio lighting uses tungsten lamps.

Twin lens reflex (TLR) A camera which has two lenses of the same focal length—one for viewing the subject and another lens for exposing the film. The viewing lens is mounted directly above the taking lens.

U

Underexposure Insufficient exposure of film or paper which reduces the contrast and density of the image.

Z

Zoom lens Alternative name for a lens having a range of focal lengths. One zoom lens can replace several fixed focal-length lenses, but results are likely to be inferior.

Index

Photographic credits

Timothy Beddow 37, 40, 55
Peter Beny/Colour Library International 61
Steve Bicknell/Eaglemoss 63 (top left and right)
Anthony Blake 33
Ron Boardman 28 (top), 53, 74 (bottom left and bottom right)
Michael Boys/Susan Griggs 19 (top), 34 (centre), 73
Dan Budnik/John Hillelson 58 (right), 88 (top right and centre), 92
John Bulmer 28 (bottom), 30 (bottom left)
Michael Burgess/The Picture Library 43 (top)
Michael Busselle 16, 52, 54 (bottom)
Michael Busselle/Eaglemoss 39 (top and centre), 66, 67, 70, 71, 72, 78 (top), 81 (bottom)
Ed Buziak 44 (top), 47 (bottom)
Julian Calder 74 (top and centre), 75, 76 (left), 79
Colour Library International 29, 89
Anne Conway 56 (top left), 60 (bottom)
William Cremin/Robert Harding 56 (bottom)
Ray Daffern/England Scene 30 (centre bottom)
England Scene 31 (bottom), 34 (right)
Lief Ericksen/Aspect 46
Robert Estall 93 (centre)
Jon Gardey/Robert Harding 10 (top)
John Garrett 23, 27 (bottom), 33 (top right), 36 (top), 39 (bottom), 45
Robert Glover 88 (bottom)
Greek National Tourist Office 24 (right)
Richard and Sally Greenhill 7, 9 (top and bottom), 14, 15, 17 (top and bottom), 26 (bottom), 30 (top), 33 (bottom), 35 (top), 65, 69 (bottom)
Alfred Gregory 59 (top), 90
Robert Harding 8, 19 (bottom)
Eric Hayman 47 (top), 93 (top)
Nick Hedges 68
Steve Herr/Vision International 57 (top)
Andreas Heumann 50 (top)
Chris Hill 58 (left)
Suzanne Hill 21, 31 (top), 62 (centre left and bottom left), 63 (bottom), 64 (top and bottom), 69 (centre)
Angelo Hornak/Eaglemoss 84, 85, 86, 87
Helen Katkov 42
David Kilpatrick 82 (centre left and bottom left)
J. Alex Langley 4
Sheelah Latham 56 (top right)
Lawrence Lawry 49
Lawrie Lewis 93 (bottom)
Alexander Low/John Hillelson 41 (bottom), 60 (top)
David R MacAlpine 41 (top)
Tim Megarry 22 (bottom)
David Morey 76 (right)
Sanders Nicholson/The Picture Library 51
Alasdair Ogilvie/Eaglemoss 12, 13
Vincent Oliver/Eaglemoss 50 (bottom left and centre)
Clay Perry 35 (bottom)
Rémy Poinot 48
Spike Powell 11 (top)
Clive Sawyer 38, 91
Clive Sawyer/ZEFA 6
Anthea Sieveking/ZEFA 62 (right)
John Sims 57 (bottom), 59 (bottom), 83 (top and bottom)
Jack Taylor 24 (left), 25
Patrick Thurston 44 (bottom)
Richard Tucker 27 (centre right)
John Walmsley 69 (top)
Malcolm Warrington 77
Malcolm Warrington/Eaglemoss 1, 2, 3, 10, 11, 18, 20, 26 (top), 32, 43 (bottom), back cover
Chris Alan Wilton 78 (bottom)
Adam Woolfitt/Susan Griggs 23 (top left), 54 (top), 80, 81 (top)

Artwork credits

Jim Bamber 20, 26, 32
Drury Lane Studios, 43, 70, 71, 72

Editorial credits

The Consultant Editor Christopher Angeloglou is an Assistant Editor of *The Sunday Times* and was the first Editor of *You and Your Camera*. He worked as a photographer on *The Sunday Times Colour Magazine* when it first started and later became the Picture Editor.

Contributors: Michael Busselle, Mark Cummins, Richard Greenhill, David Kilpatrick, Raymond Lea, David Pratt, David Reed, Suzanne Walker

Cover: Ekhart van Houten
Page 4: J. Alex Langley/Aspect